IRELAND'S
Greening of the World

Seth Linder is a writer, researcher and journalist with an abiding interest in Irish history and culture who has worked extensively within the island of Ireland. He has researched and written numerous trails, panels, historical exhibitions, short films and booklets, as well as non-fiction books, film scripts, plays and television dramas. His most recent book, *Belfast Walks*, a historical guide to the city and its beautiful hinterland, was published by The O'Brien Press in 2017. For the past 20 years Seth has been based in the lovely County Down village of Rostrevor.

Tourism Ireland is the organisation responsible for marketing the island of Ireland overseas as a holiday destination. Tourism Ireland has two clear goals – to increase tourism to the island of Ireland; and to support Northern Ireland to realise its tourism potential.

Tourism Ireland delivers world-class marketing programmes in 21 markets across the world and reaches a global audience of over 600 million each year. Targeted marketing activity includes: advertising online, on TV and outdoor sites, in cinemas and in newspapers and magazines; eMarketing; publicity; co-operative marketing with carriers and other partners; and promotions to the travel trade and consumers.

IRELAND'S
Greening of the World

Seth Linder

Tourism
Ireland

First published 2019 by

The O'Brien Press Ltd.,

12 Terenure Road East, Rathgar, Dublin 6, D06 HD27, Ireland.

Tel: +353 1 4923333; Fax: +353 1 4922777

E-mail: books@obrien.ie Website: www.obrien.ie

The O'Brien Press is a member of Publishing Ireland.

ISBN: 978-1-78849-104-4

5 4 3 2 1

23 22 21 20 19

Printed by Nicholson Bass, Northern Ireland

Managing Editor Tourism Ireland – Patrick Lennon

Published in

DUBLIN
UNESCO
City of Literature

Contents

Foreword

This book is a tribute to our diaspora. Tourism Ireland with the Department of Foreign Affairs and Trade undoubtedly led the way on 'greening' of iconic landmarks for Saint Patrick's Day. However, the initiative could never have achieved its current global scale without the support of many of the millions of Irish men and women who left these shores and have gone on to make their mark on the world.

One outstanding example is Rodney Walshe. Rodney, who left Ireland in 1959, was Ireland's longest-serving Honorary Consul General to New Zealand, serving for almost 40 years, from 1976 to 2015. He epitomised everything good about Ireland, assisting legions of Irish travellers to New Zealand and promoting Irish tourism there as well. It was Rodney who arranged to have Auckland's iconic Sky Tower light up in green to mark St Patrick's Day, paving the way for what we know today as Tourism Ireland's Global Greening initiative.

The project is still growing. Our nearest neighbours in Britain have greened the London Eye, Nelson's Column and many other landmarks across the country. Our friends and relations in North America, who had been colouring the Chicago River green for many years, have brought greening to a new level. South America and Africa have embraced the project. In Australia, the Sydney Opera House first went green on the 200th anniversary of a historic event hosted by the reforming Governor of New South Wales, Lachlan Macquarie.

We Irish have a capacity for humour, which is just as well since in 2011 Tourism Ireland took credit for the greening of London's Big Ben, when in fact the bell tower on Big Ben is always green!

The support of the Department of Foreign Affairs and Trade and the diplomatic service has been invaluable in broadening the reach of the project – helping to bring in the Great Wall of China, the Pyramids and Sphinx in Egypt, Matsue Castle in Japan, the equator sign in Uganda, and many other world icons and landmarks. Our new European partners have also been great supporters, reflecting our positive relationships across the continent.

A warm thank you to everyone who has played a part in making this project what it has become, members of the diaspora across the world and, especially, my colleagues in Tourism Ireland who work tirelessly promoting our great island around the globe.

Niall Gibbons, CEO, Tourism Ireland

Preface

Is there anywhere else in the world that has their special day shared so enthusiastically by so many other countries across the globe? After all, it is no small matter to ask for another country's most iconic landmarks to be lit up in green to celebrate what is essentially your own national holiday.

So why has the Global Greening campaign been so remarkably successful, now with over 300 international buildings and landmarks going green every year?

Researching this book, I was struck by how many greenings materialised simply because the person or persons responsible for making the decision had a special place in their heart for the island of Ireland. Usually, it was memories of a particularly happy holiday, the all embracing friendliness of a people who love to engage, the Irish way of living in the moment and inviting others to join them.

And while the Irish diaspora has played a huge role and my sincere thanks to all those expats who have contributed so mightily to the greenings and this book – so have those whose love of Ireland has seen them enthusiastically organise greenings in their home town or city.

The Irish sense of fun certainly helps. So does the universal appeal of Irish music and dance. And when the world wants to party, there is just one country it turns to.

The greenings began at a time of global despondency, with the repercussions of the Credit Crunch really beginning to bite. And, in a way, their inception started the fightback. Who better to lead the world back to happier times than the Irish and the international saint of parties, St Patrick?

Seth Linder

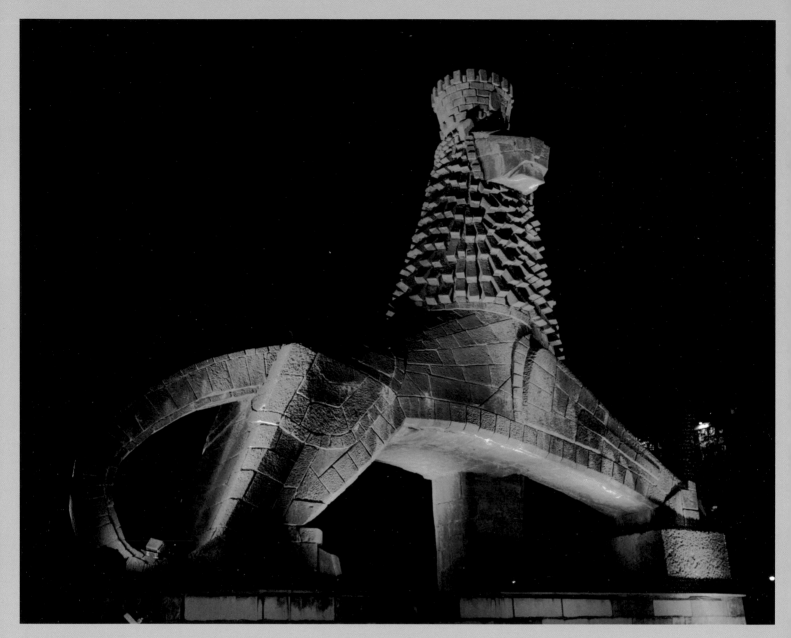

Lion monument in Addis Ababa, Ethiopia

Introduction: Ireland's Global Greening Lights Up the World

Like all great ideas, it is simplicity itself – to raise the profile of the island of Ireland by turning the world's most famous buildings and landmarks green each St Patrick's Day. After all, what other country has a national day that has become an international celebration?

The Tourism Ireland initiative began on 17 March 2010, when the spectacular Sydney Opera House was bathed in shades of green.

The world's imagination was gripped, and the Global Greening has spread every year since. The London Eye, Niagara Falls, Rome's Colosseum, the Leaning Tower of Pisa, the Gateway of India and many dozens of others have joined the campaign.

The Global Greening has extended to the Pyramids of Giza, one of the original Seven Wonders of the World, and the Great Wall of China and Rio de Janeiro's *Christ the Redeemer* statue, two of the New Seven Wonders.

Greenings have made important statements too. The lighting of the newly reopened One World Trade Center in 2017 was an act of solidarity that symbolised the deep relationship between New York and the Irish people.

But the Irish love of fun has not been forgotten, and has been shared with countries around the globe in greenings of ice-swimming, shamrock-eating polar bears, giant kangaroos, Kenyan rhinos and the world-famous statue of a little boy peeing!

By 17 March 2018, over 300 famous landmarks all over the world had signed up to the green revolution. The numbers continue to grow. Behind each individual greening lies a network of stories and connections. They reveal both the global reach of the Irish diaspora and the world's view of Irishness as an empowering attitude to life to be shared by all.

Indeed, there have now been so many Global Greenings that we simply don't have space to feature them all, but we hope that you will be entertained by this selection of some of the most interesting.

A Message from An Taoiseach, Leo Varadkar

Tourism Ireland's Global Greening project is a powerful symbol of the impact of the Irish abroad and is an expression of our reach, our shared values and our ambition. The Global Greening project, like our diaspora, stretches across the world, to every continent, going beyond our historical connections into where we can now be found.

St Patrick's Day enables us to reach out to our wider family, to connect, to reunite and to spread our welcoming message abroad. It is also a time when many people from around the world visit Ireland to experience our unique heritage, culture and landscape, and the warmth and friendliness of our people.

As Minister for Transport, Tourism and Trade I was proud to support the development of this initiative and I encouraged those in charge of our public buildings to take part in 'the Greening'. Today, as Taoiseach, I am proud to see that so many places in Ireland and around the world are involved in the project, contributing to its enormous success.

Congratulations to everyone that has been associated with this project here at home and around the world.

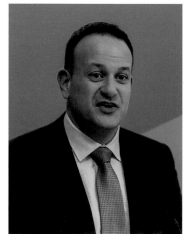

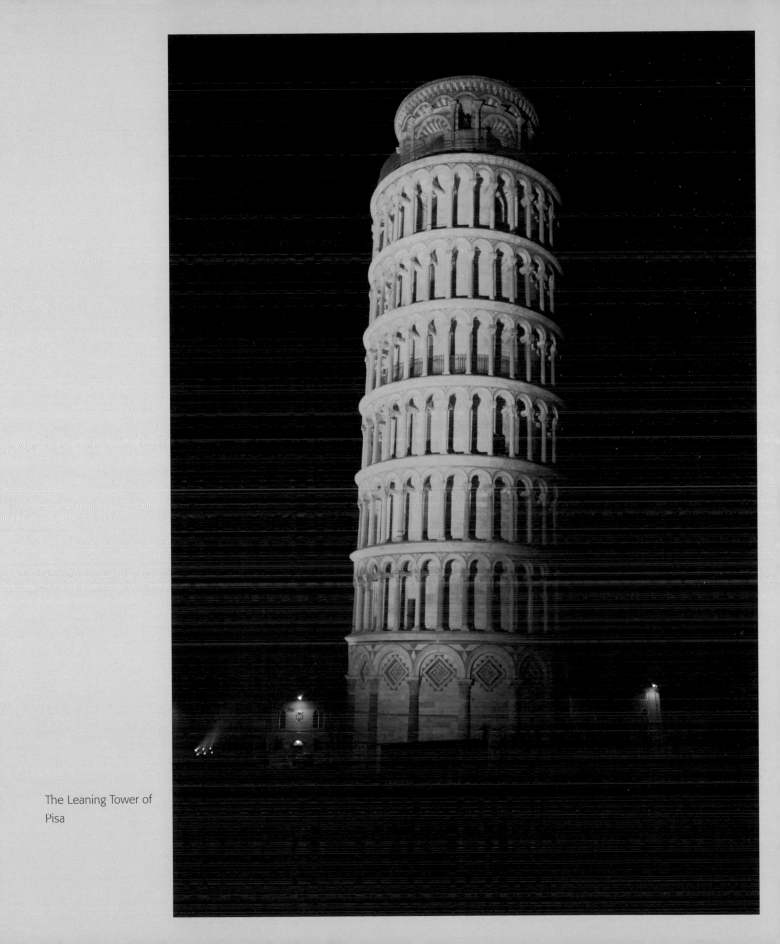

The Leaning Tower of
Pisa

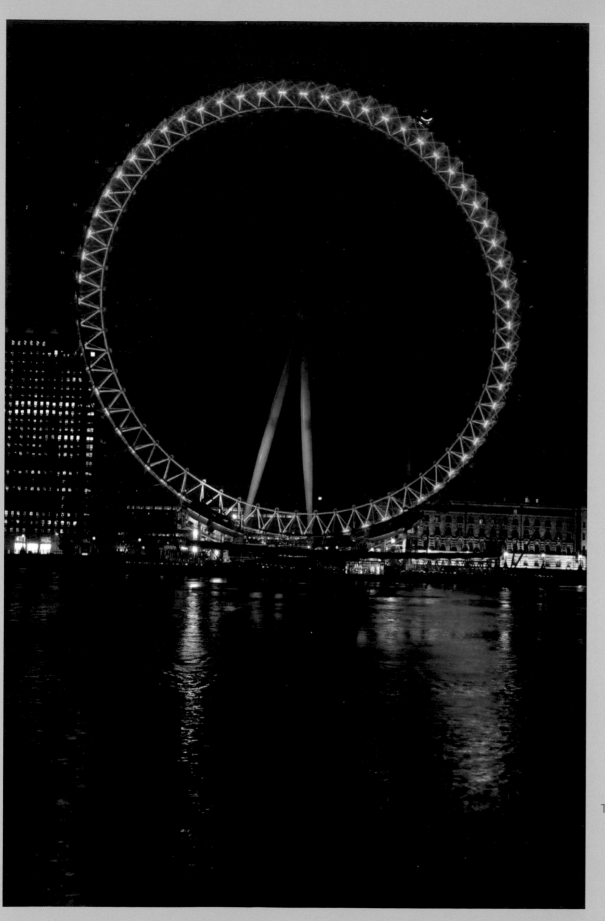

The London Eye

2010

When Did the Global Greening Start?

Some might say that the origins of the greenings lie in the dye first added to the Chicago River back in 1962, putting the city's St Patrick's Day celebrations on the global radar. In fact, the first greening of a landmark building came in 2009 – the year before the first official greening (that of the Sydney Opera House).

It was then that Rodney Walshe, Ireland's longest serving Honorary Consul General to New Zealand, suggested the greening of Auckland's Sky Tower. Locals loved it, and the Sky Tower has been a highlight of the city's St Patrick's Day celebrations ever since.

The same year, the team in the ever-innovative Tourism Ireland office in Australia were brainstorming ideas to promote Ireland. Quite independently, the notion of greening the white 'sails' of one of the world's most beautiful buildings, the Sydney Opera House, was suggested.

And so, on 17 March 2010, that dramatic image was relayed around the world and a new St Patrick's Day tradition was born.

Sydney Opera House, Australia

The first official greening began just about as far from the island of Ireland as it is possible to get, and no one could have wished for a more dramatic debut. On 17 March 2010, as onlookers lined the harbour and revellers raised their glasses in the historic Rocks area of Sydney, the spectacular white sails of the Sydney Opera House were illuminated in green.

The greening began as a challenge. Two hundred years beforehand, Lachlan Macquarie, newly appointed Governor of New South Wales, had declared 17 March a day of music and celebration for the (largely Irish) convict workers in Sydney.

Known for their innovation, Tourism Ireland Australia decided that the bicentenary was too auspicious to go uncelebrated. But how could they do justice to such a significant event? Turning one of the world's most famous and visually stunning buildings green in honour of Ireland's patron saint seemed the ideal solution.

Tourism Ireland CEO Niall Gibbons recalls his feelings when he saw a mock-up of the plan a few months before the big day: 'At the height of the Credit Crunch, at what was such a difficult time for the world, I remember that something hit me on an emotional level, while visualising this. It seemed to me something that would have a huge impact.'

And so it proved. The stunning images raced around the world, conveyed by social media, newspapers and television. The Global Greening was born.

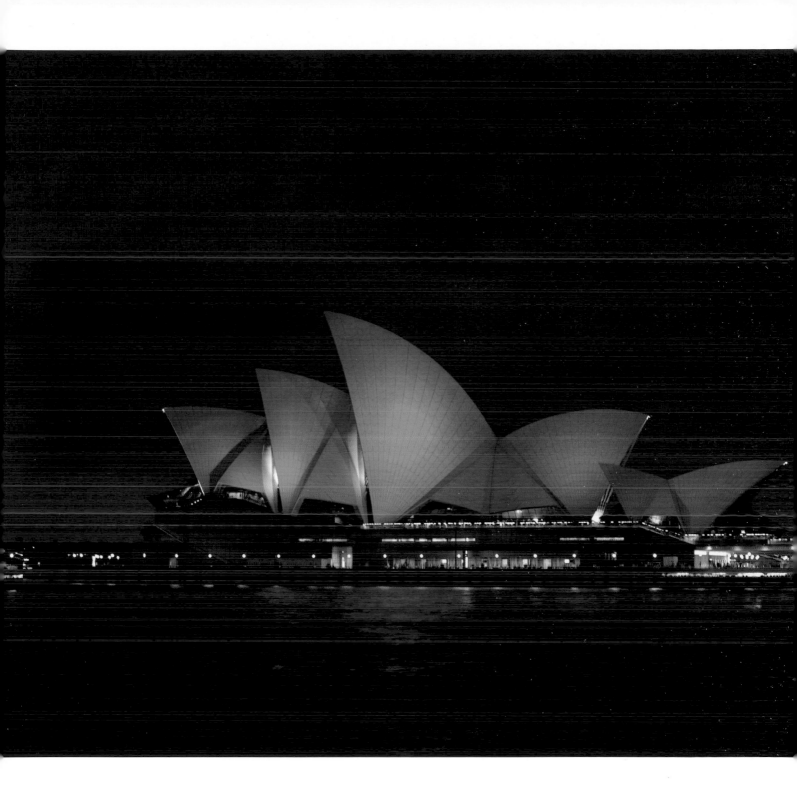

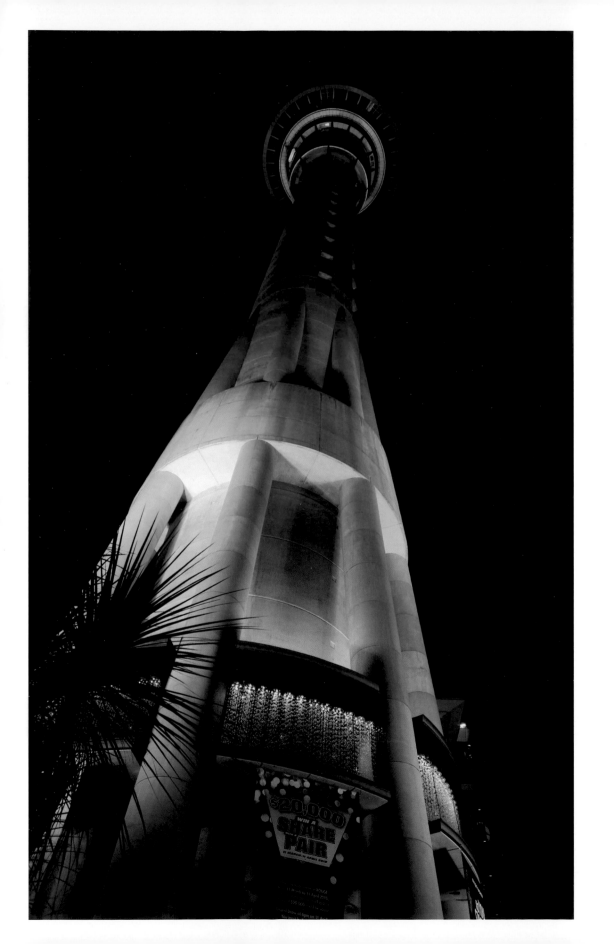

Sky Tower, Auckland, New Zealand

On 17 March 2009 the Auckland Sky Tower turned green for the first time, and created the spark that ignited the flame of Tourism Ireland's Global Greening.

Each day of the year, as the world rotates on its axis, the sun sets first in New Zealand. Thus, the Sky Tower goes green ahead of the rest of the world, and as the wave of darkness moves inexorably from east to west, so does the green beam – spreading from country to country, landmark to landmark, and illuminating Ireland's national day worldwide.

It had taken a little time to convince the Auckland Sky Tower management to 'go green'. However, some smooth talking from Honorary Consul General Rodney Walshe – aided by a tincture of Bushmills whiskey and a reminder that more than 18 per cent of the New Zealand population are of Irish descent – convinced them that a green Sky Tower on 17 March would be welcomed by all.

So, the Sky Tower went green and has gone green every year since, without fail. In fact, it became an annual event for guests, including visiting Irish government ministers, of Tourism Ireland and the Honorary Consul General to gather beneath the tower and watch as the green lights are switched on, and – slowly but steadily, in the waning light – the Sky Tower becomes greener and greener, visible from just about everywhere across the city of Auckland.

In New Zealand the greening has now spread to many landmarks, including the Auckland Harbour Bridge, the Auckland War Memorial Museum, the Palmerston North Clock Tower, and the New Brighton Pier, Christchurch (switched on by the television character 'Mrs Brown'). In 2014 the sign at New Zealand's Scott Base in Antarctica was greened!

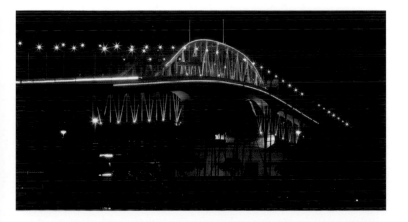

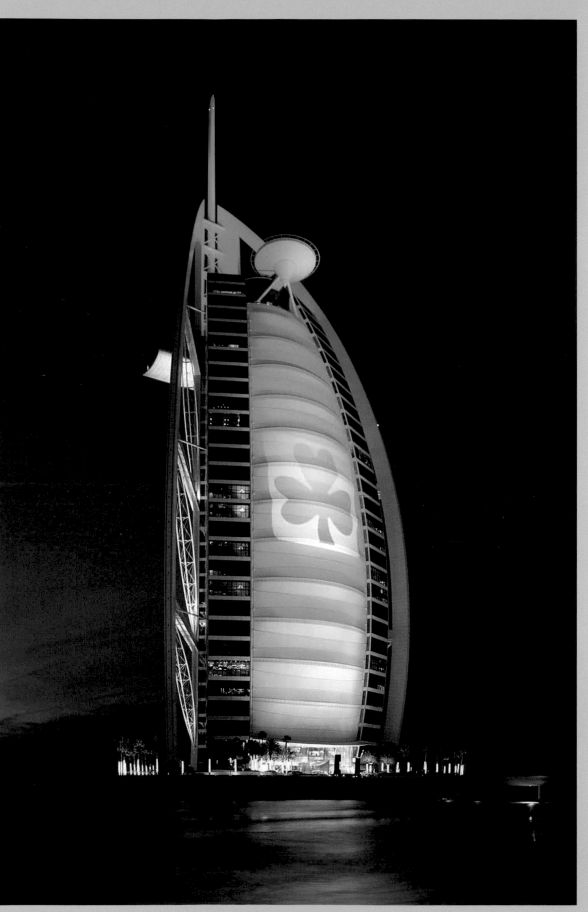

Burj Al Arab Hotel,
Dubai, UAE

2011

Global Icons Make an Impact

No one could have predicted the impact of the Sydney Opera House greening. The world's media loved the novelty, and the images of the 'green sails' went viral. Tourism Ireland offices in other parts of the globe now started to look at their own iconic landmarks.

But there was another dimension to this response. With the global economic recession biting hard, the world was in desperate need of cheering up. Who better than the Irish to raise its spirits?

Among the first of this second generation of icons was the London Eye, the big wheel that dominates the London skyline above the Thames. From Downing Street, Prime Minister David Cameron and Taoiseach Enda Kenny led a delegation to Westminster Bridge to watch the greening. They had just reached the bridge when the Eye was swathed in a pool of green, reflecting over the river.

That cheering light – a signal that we would come through to better times – was also seen at several other icons around the world to celebrate St Patrick's Day. These included Nelson's Column, just along the Thames, the Empire State Building in New York and Madrid's La Puerta de Alcalá ('the door to Alcala').

The Moulin Rouge became the 'Moulin Vert' and the Manneken Pis in Brussels became an Irish boy in tweed trousers, Aran sweater and tweed cap. One way or another, the world was smiling again, and Ireland's global profile took a massive jump.

The London Eye, UK

17 March 2011. Winter was coming to an end but there was little else to cheer. The world was still in the grip of the economic meltdown that followed the Credit Crunch of 2007 and, for both the Irish and the British, more years of austerity seemed to beckon. But St Patrick's Day is designed to lift the spirits, and this day something particularly special was planned to ease the gloom.

As Irish Taoiseach Enda Kenny and British Prime Minister David Cameron walked out of a reception in Downing Street towards the nearby Houses of Parliament, anxious members of the Tourism Ireland team checked their watches. At 6pm the London Eye, one of the capital city's most popular visitor attractions, was to be lit in green.

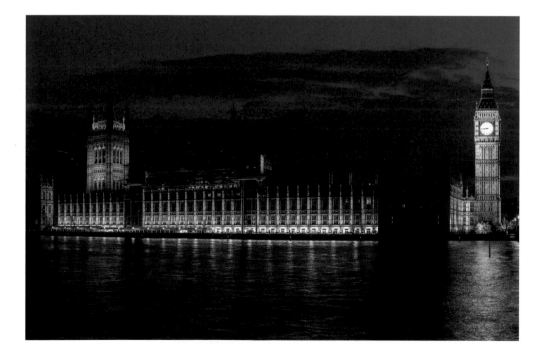

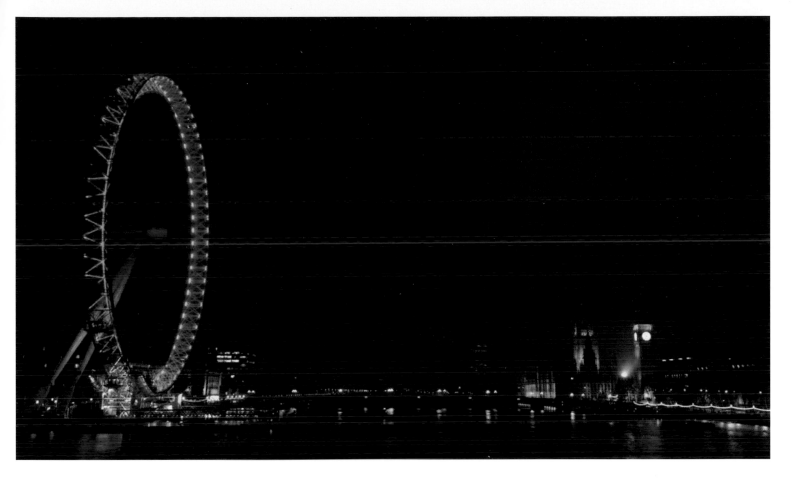

With just a few minutes to go, the Eye remained unlit. Just as the two men and their entourages reached Westminster Bridge, the Eye, like a gigantic Catherine wheel, burst into shades of green before them.

For those watching from the terrace at the Houses of Parliament, just across the Thames, this moment was deeply symbolic: almost like a spring awakening after a long cold winter! Watching the spectacle in the stillness, there was a tangible sense of pride among all those who had worked to make it happen.

Daniel Mulhall, then Ireland's Ambassador to the UK, recalls his reaction to the annual spectacle. 'Each year of my time in London, I was thrilled to stand on the terrace of the House of Commons to see the extraordinary London Eye sparkle in green.'

Moulin Rouge, Paris, France

When you're looking to perform the very first greening in France and you really want to capture the public imagination, where do you choose? With so many iconic buildings and monuments, it must have seemed an impossible task. But then someone came up with the irresistible idea of turning the Moulin Rouge into the 'Moulin Vert'!

Luckily for this ambitious project, then Ambassador of Ireland to France Paul Kavanagh was an enthusiastic supporter of the greenings. With his help and the cooperation of the Moulin Rouge's management, the home of the cancan became the star of France's 2011 St Patrick's Day celebrations.

There are few more recognisable landmarks in France than the red windmill that stands atop the Moulin Rouge, near Montmartre in the Paris district of Pigalle. The most celebrated stars of the cabaret venue, famed for its musical entertainment since the end of the

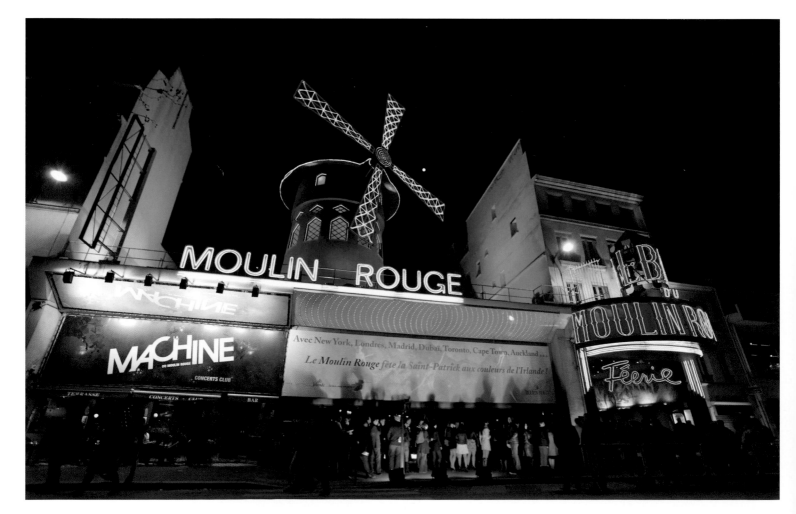

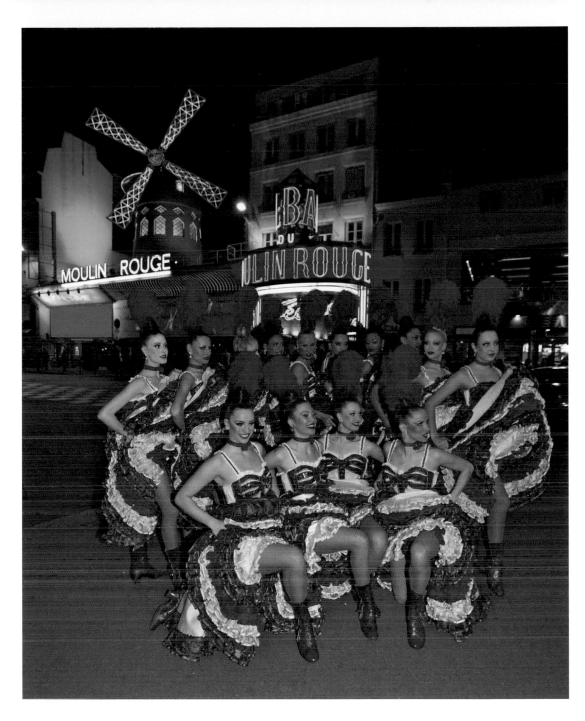

19th century, have long been its cancan dancers. So, what could provide a better start to France's greening campaign than the dancers performing outside the Moulin Vert for the attention of the world's media?

It would prove an ideal launch for what has since been a long list of outstanding French greenings, the widespread media reaction including front-page coverage in leading French newspaper *Le Figaro*.

La Puerta de Alcalá, Madrid, Spain

With the impact of the Sydney Opera House greening reverberating around the world, Tourism Ireland offices in other countries now looked to iconic locations they could try themselves. That one of the world's most spectacular buildings had set the ball rolling proved to be a major incentive when potential sites were being discussed with local authorities

For Tourism Ireland Spain, the first choice was a much-loved landmark in the capital city, Madrid – La Puerta de Alcalá ('the door to Alcala'). Standing in Plaza de la Independencia, just yards away from the main entrance to the Retiro Park, the 19.5 metres (64 feet) tall gateway had been built by Charles III in 1778. It is the first triumphal arch constructed in Europe after the fall of the Roman Empire, ahead even of the Arc de Triomphe.

There was an added incentive, as Irish President Mary McAleese was visiting the city on 15 March 2011, and – with the assistance of Ambassador of Ireland Justin Harman – permission for the greening was soon forthcoming. So, two days before St Patrick's Day, President McAleese and her cavalcade witnessed the first-ever Spanish greening.

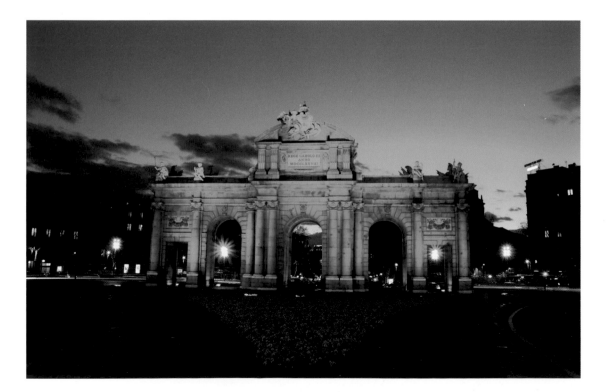

Manneken Pis, Brussels, Belgium

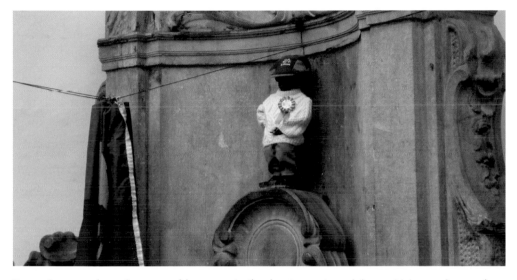

Sometimes a shared sense of humour is the best way to celebrate Irishness in another country. That was the essence of the eye-catching greening of the famous Manneken Pis ('Lil Piddler') in Brussels. This is a bronze sculpture of a naked little boy peeing into a fountain, an expression of local humour much loved by the people of the city for four centuries.

Over the years it has become a tradition to dress the little boy in various national costumes, football team outfits and the like – over 400, in fact. Thanks to representations from the Irish Embassy and Tourism Ireland's Danielle Neyts, it was the turn of the Irish on St Patrick's Day 2011.

First of all, they had to decide what exactly is the Irish national costume. Their answer? Aran sweater, tweed trousers and tweed cap, swiftly made by skilled artisans in Donegal to the little boy's measurements.

The night of the greening started with a ceremony at Brussels Town Hall attended by Ambassador Tom Hanney, Danielle and the Friends of Manneken Pis. The group then paraded to the statue for the grand unveiling. What they didn't know was that the fountain had been switched off – when the curtain was pulled back, it was suddenly switched on, and the be-costumed Manneken Pis did what he does best over the assembled guests!

An Irish piper played, Irish songs were sung and – as has happened many times since – a lot of fun was enjoyed by Belgian, Irish and visitor alike.

Battersea Power Station, London, UK

On St Patrick's Day 2011, one of the most distinctive buildings in London went green. The vast Battersea Power Station, with its chimneys dominating the city skyline, has been a much-loved landmark since the 1930s and supplied electricity to London until the 1980s.

One of the world's largest brick buildings, the power station has featured in many films, from Hitchcock's *Sabotage* to *The Dark Knight* and *1984*. It was also on the cover of Pink Floyd's 1977 album *Animals*, but its starring role was definitely on St Patrick's Day 2011, when its two great riverside chimneys glowed green as night fell.

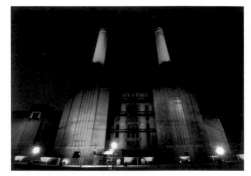

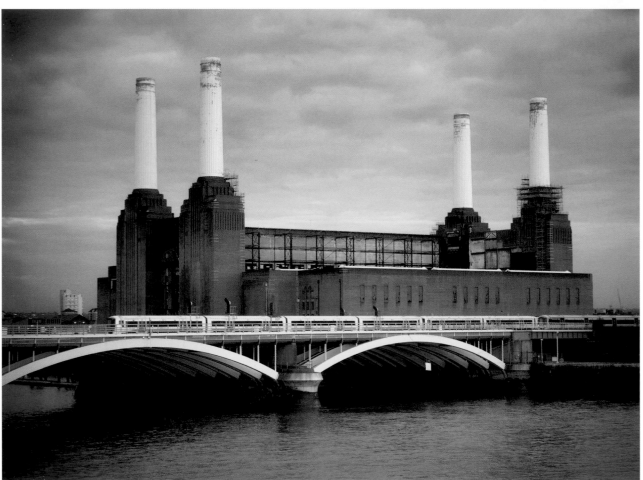

Table Mountain, Cape Town, South Africa

The vast form of Table Mountain, with its instantly recognisable three-kilometre plateau, was voted one of the New Seven Wonders of the world. For the inhabitants of Cape Town, above which it looms, it is a much-loved part of life. For visitors it is one of the most spectacular sights they will ever see. But how much more so when it's green!

That was the thinking behind Tourism Ireland's approach to the City of Cape Town to see if South Africa's most famous landmark could join the global St Patrick's Day celebrations in 2011. Thankfully, the answer was 'yes', and former Irish President Mary Robinson was in attendance to witness the amazing spectacle. She would certainly have been pleased that the lighting was powered by green renewable energy and by the profile the event gave to Irish charities in South Africa. Table Mountain has been greened several times since.

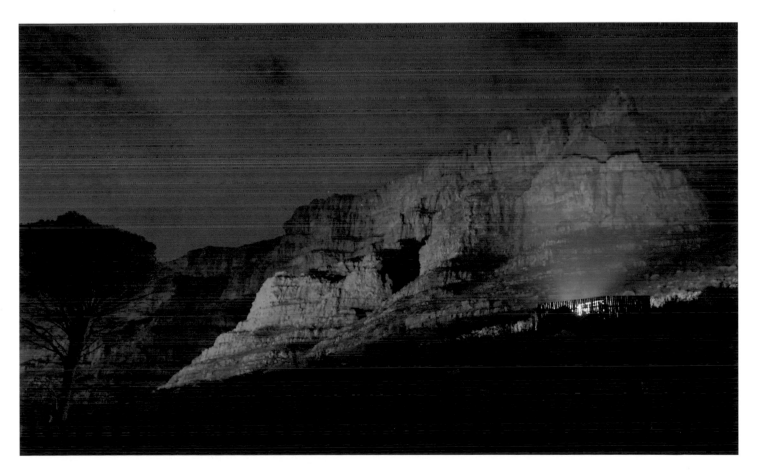

Burj Al Arab Hotel, Dubai, United Arab Emirates

With its distinctive sail-like shape, the Burj Al Arab ('Tower of the Arabs') is one of the world's most extraordinary hotels. Built on an artificial island in Dubai and connected to the mainland by a curving bridge, it is also one of the highest. In other words, a magnificent candidate for a greening!

That was the view of Tourism Ireland CEO Niall Gibbons when he enjoyed the amazing views from the Al Muntaha restaurant at the top of the hotel over lunch with fellow Irishman Gerard Lawless, President and CEO of the Jumeirah Group, which owns the Burj Al Arab. Over nearly two decades Gerard had built the company into one of the world's best known luxury hotel brands, and he has been a crucial figure in the development of Dubai.

Impressed by photos of the Sydney Opera House and Auckland Sky Tower greenings, Gerard happily agreed to Niall's request. On the day, the event was mightily enhanced by the presence of the world-renowned Irish musician and composer Professor Mícheál Ó Súilleabháin and five members of the Irish National Youth Orchestra, who played in front of the hotel as it was bathed in green. They were joined by, among others, the Ambassador of Ireland to the United Arab Emirates, Ciaran Madden.

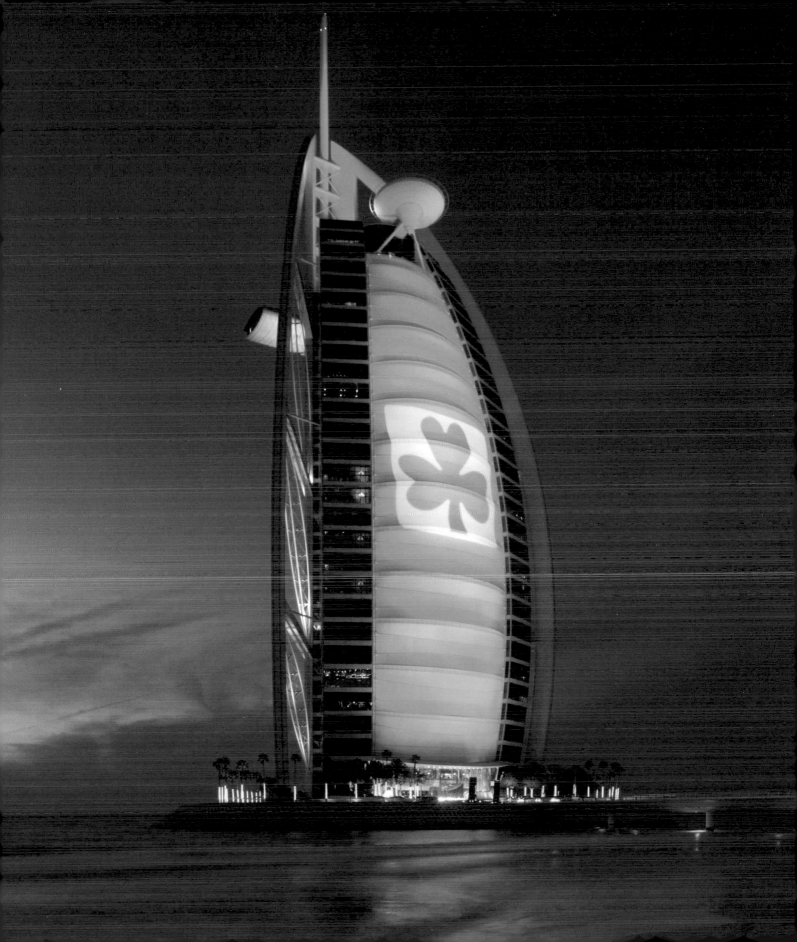

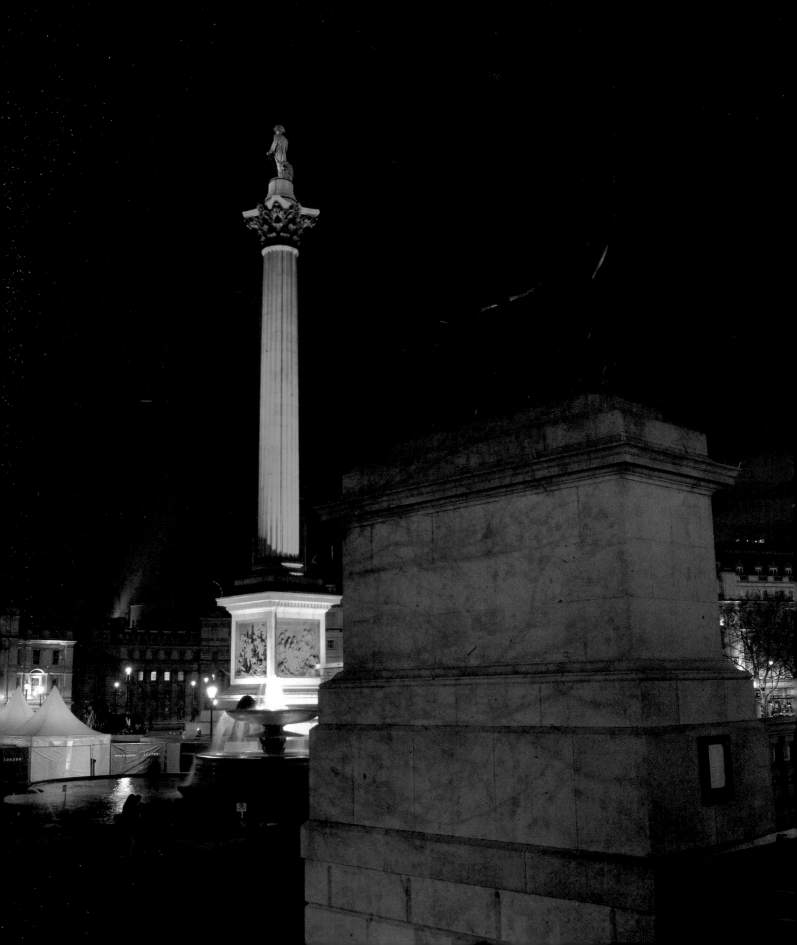

Nelson's Column, London, UK

Standing 51.5 metres (169 ft) high, in the heart of London's Trafalgar Square, Nelson's Column commemorates Admiral Lord Horatio Nelson, whose victory at Trafalgar against Napoleon's fleet made him Britain's greatest naval war hero. As London's favourite area for celebrations, it was the perfect location for one of the UK's first greenings

CN Tower, Toronto, Canada

Different kinds of lighting have become a speciality of the CN Tower in Toronto, the tallest tower in the western hemisphere (if you include its antenna) at 553.2 metres (1,815 feet). In 2011, the tower was the site of Canada's first ever greening. It would be a hard act to follow, but the very next year Canada managed something very special indeed!

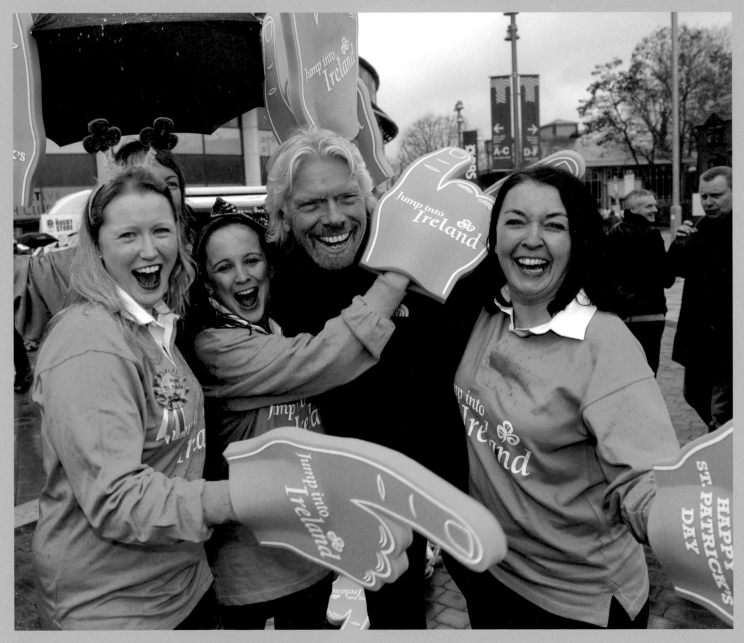

Richard Branson and Tourism Ireland at Twickenham, UK

2012

Momentum Gathers

This was the year the green message began to spread in earnest. At London's Twickenham stadium, home of English rugby, twenty thousand green hands rose to acclaim St Patrick. So what if Ireland lost to England that day? All the more need for a party!

The greenings reached the west coast of the US when San Francisco's Coit Tower and Town Hall joined the fun. Prince Albert's affection for the ancestral homeland of his mother, Grace Kelly, led to the Prince's Palace in Monaco lighting up, while the Leaning Tower of Pisa leant in green, to the delight of hundreds of selfie-taking revellers.

Now people were doing it for themselves too. In what would become a growing trend, Irish student Ben Finnegan arranged a greening of the main plaza in Salamanca, Spain, where he was studying on the Erasmus exchange programme.

The Niagara Falls in the US and Canada; the home of German-speaking theatre, Vienna's magnificent Burgtheater; and the Cibeles Fountain, where Real Madrid fans go to celebrate, all joined the fray. Even one of the UK's most iconic department stores, Selfridges in Oxford Street, London, where Tourism Ireland has its UK office, went green. Anything seemed possible. The momentum was gathering.

San Francisco City Hall/Colt Tower, USA

The magnificent City Hall is so vast that it occupies the space of two full city blocks. It was designed by Arthur Brown Jr, who also designed San Francisco's Colt Tower, dedicated to the city's firemen and one of the best viewing points in the city. The two have another significant connection: both took part in the 2012 Global Greening, the first in the west of the US.

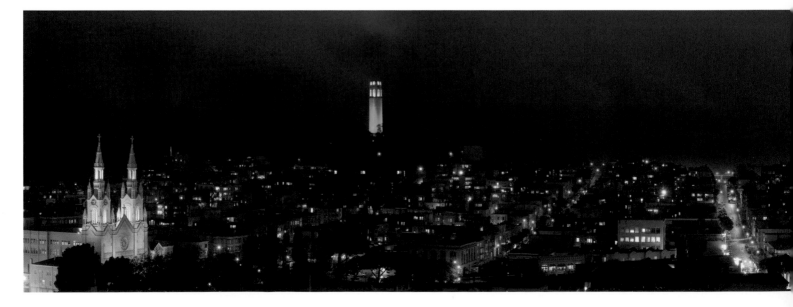

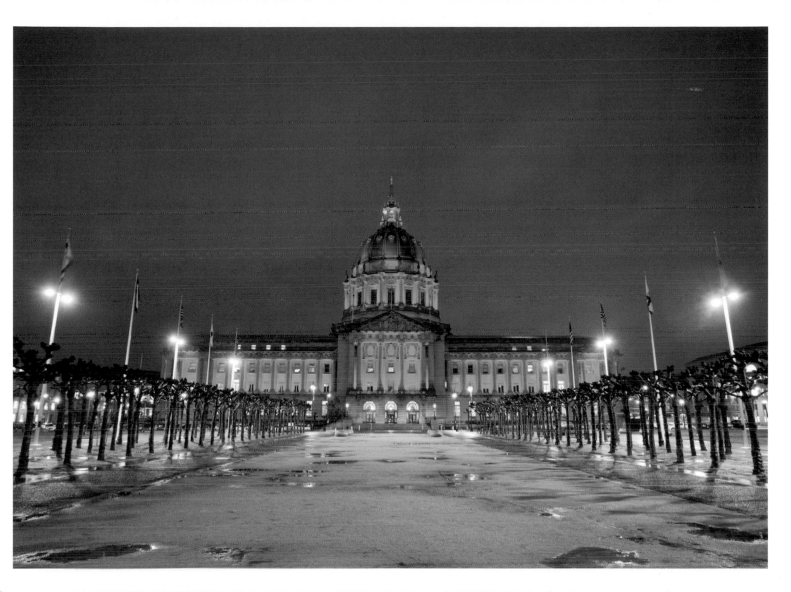

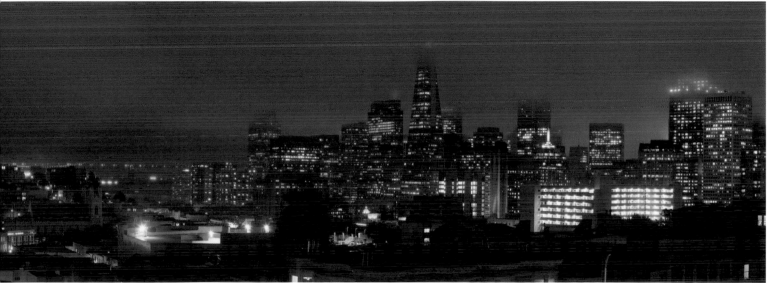

Prince's Palace, Monaco

Ireland has always claimed Grace Kelly, also known as Princess Grace of Monaco, as its own. Although the elegant film star of the 1950s was born in Philadelphia, she had a strong affection for Ireland, making several visits to research her roots (her grandfather John Peter Kelly emigrated to the US from Mayo). On one such trip she even bought the old family homestead. Her son, Prince Albert, retains the strong family connection to Ireland, where he has been welcomed many times.

So, it was with great delight that Tourism Ireland heard the news that Prince Albert had agreed to the greening of the Prince's Palace in Monaco in 2012. Traditionally the private residence of the ruling prince, the 13th-century palace was beautifully restored to its former glory by Albert's father, Prince Rainier III. The magnificent building has been part of the Global Greening campaign ever since its debut in 2012.

His Serene Highness Prince Albert of Monaco (left) with then Irish Ambassador to France and Monaco Paul Kavanagh and his wife Rosemary

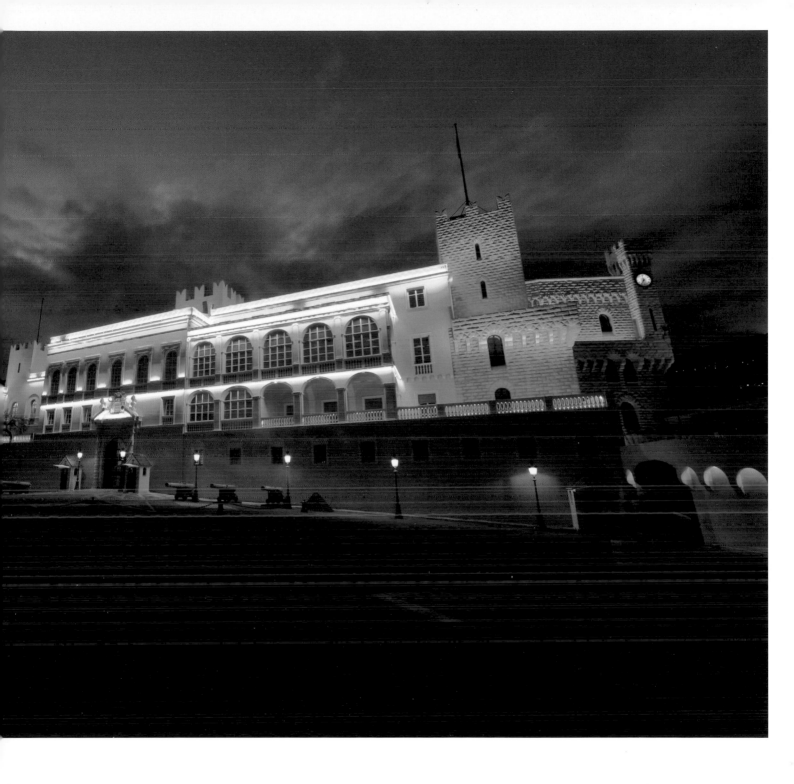

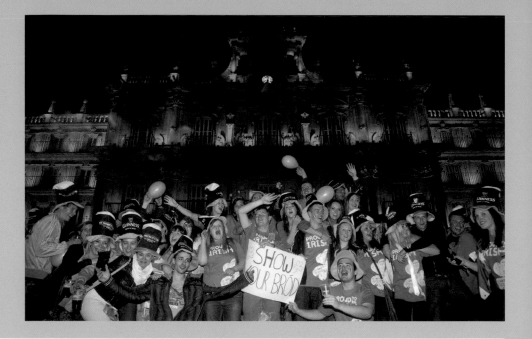

THE GREENING OF SALAMANCA PLAZA

In February 2012, whilst on an Erasmus exchange programme in Salamanca, in northern Spain, I set out to try and get the Plaza Mayor [Main Plaza] of the city illuminated green for Saint Patrick's Day.

Despite receiving a resounding 'NO' from every source of support that I sought, I decided to keep trying. Members of the Tourism Committee in Dáil Éireann thought it was a great idea but one for next year! There just wasn't time.

However, after a month of emails, phone calls and letters, I finally received a call from the office of the Mayor of Salamanca, Alfonso Fernandez Mañueco, just four days before St Patrick's Day. They thought it was a fantastic idea and would be delighted to implement it! Overcome with emotion, I decided to tell the Irish media about the event by sending emails to various broadcasters.

The media response was amazing. Practically every Irish national media agency was looking to talk to me and find out more about the story. I found out that various radio programmes on RTÉ were fighting over who got to broadcast the interview!

The Spanish national and local media also loved the initiative and decided to share the story across Spain. Even the local Salamanca community really embraced the idea of celebrating Saint Patrick's Day in their city centre. With the support and help of my Erasmus and Spanish friends, we began publicising and preparing for the event, the first Irish heritage project of its kind in the city. We were able to spread the word across Spain and

even got local businesses involved. As a result of our efforts, over 1,000 people came to the plaza for the event, from places like Madrid, Galicia, Malaga and Seville.

After the event I was honoured to receive a letter of congratulations from the President of Ireland as well as the Tánaiste, Eamon Gilmore, and the Minister for Tourism, Leo Varadkar. The event was even discussed during leader's questions in the Dáil. A couple of weeks after the event I was delighted to welcome the Irish Ambassador to Spain to Salamanca and had the pleasure of introducing him to the Lord Mayor!

When I returned to Ireland the following year, still enthused from the greening experience, I set out to try to 'green' some local landmarks here in Maynooth. I was delighted to see the likes of Maynooth University and UCC respond so enthusiastically to my request to light part of their campuses green for St Patrick's Day. The US Embassy in Dublin also responded positively and agreed to light their building green. To this day I still like to try to get additional buildings on the 'greening list' and in March 2018 I was pleased to see my then employer, Mary Immaculate College in Limerick, agree to light up their campus green for the first time!

I still receive correspondence from the Mayor every year on St Patrick's Day. I am currently building a career within the international education sector, and I firmly believe that the confidence I got from achieving success despite encountering setback after setback made it one of the best and most significant experiences of my life!

Ben Finnegan

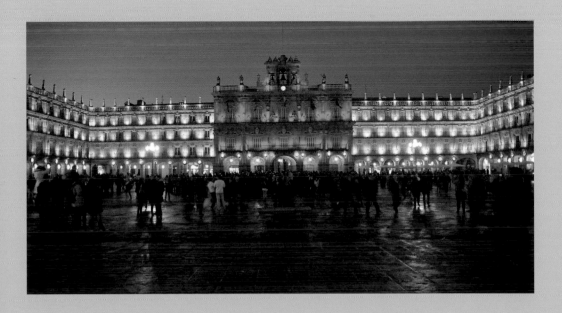

Empire State Building, New York, USA

Although no longer the world's tallest, the art-deco Empire State Building is still New York's most distinctive skyscraper and one of the most famous manmade structures on earth. Situated in Manhattan, near the start of the world's largest St Patrick's Day Parade, it provides the big day with one of its most memorable traditions – out of the darkness, a green light illuminates its top storeys and tower. Part of the tower is also lit in the green, white and orange of the Irish tricolour.

The New York St Patrick's Day Parade dates all the way back to 1762, making it probably the first in the world. At a time when 'the wearing of the green' was banned in Ireland, it became a symbol of Irish identity in America. Today, millions of spectators line the route, which starts at 44th Street and 5th Avenue, and passes St Patrick's Cathedral.

In 2002 the parade was dedicated to the 'Heroes of 9/11', including the fire fighters, police and other rescue workers. On the stroke of noon, the one-and-a-half-mile parade stopped for two minutes in silence. It is believed that in addition to the 300,000 marchers, over three million people lined the route, while Irish President Mary McAleese reviewed the parade – the first time an Irish President had done so.

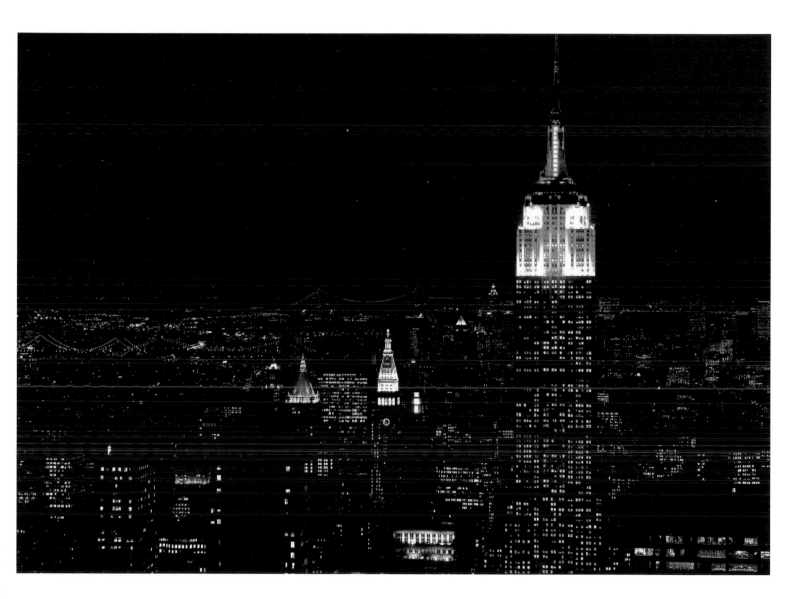

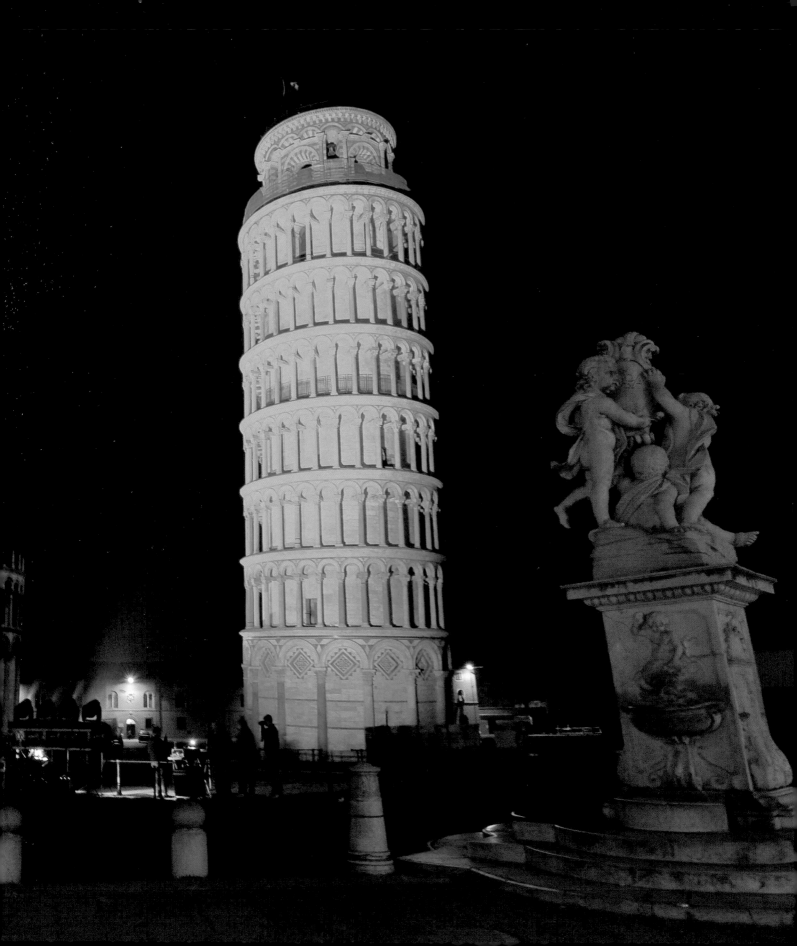

The Leaning Tower of Pisa, Italy

St Patrick's Eve, 16 March 2012, Pisa

Irish Minister for Communications, Energy and Natural Resources Pat Rabbitte TD switches on the lights. A shaft of green flows up the Leaning Tower of Pisa until the whole building is illuminated. Then, suddenly, the tower is plunged into darkness.

The crowd beneath groan and the Tourism Ireland team, who have spent months organising the ground breaking event, find their hearts in their mouths. Seconds that seem like minutes later, the green light again envelops the tower and a roar of appreciation rings out.

The Leaning Tower of Pisa – high on any list of the world's most famous buildings – has been one of the great coups of the greening revolution. It began when Tourism Ireland in Italy approached the office of the Opera della Primaziale Pisana, which oversees the historic monuments in Pisa's Piazza del Duomo. With strong support from the Archbishop of Pisa, the go-ahead was given and the lighting arranged. (Only once before had the ancient tower been lit – for breast cancer awareness.)

In subsequent years, the campaign has gained impetus. Shop windows have been used to promote the event, green balloons given out to revellers and an Instagram Green Selfie contest, organised by Tourism Ireland, has been a huge success, with entries becoming more creative each year.

Niagara Falls, Canada

When a greening combines with one of the natural world's most spectacular creations, the result is breathtakingly dramatic!

First, there is that astonishing backdrop of sound. It is believed that the word 'Niagara' comes from the Iroquoian *onguiaahra*, meaning a 'thundering noise' and referring to the impact of six million cubic feet (168,000 cubic metres) of water crashing over the crest-line every minute.

Then there's the sheer scale of the plunging water. The Horseshoe Falls on the Canadian side are some 180 feet (55 metres) high!

Finally, there is the sheer beauty of this extraordinary scene, witnessed by people on all sides of the Falls as well as on the lighting deck, as the intense, vibrant green light transforms the plunging water into a glowing green curtain.

Before the Statue of Liberty was unveiled in 1886, the 12,000-year-old Niagara Falls was the symbol of the New World. For the five million Canadians of Irish descent, the importance of such an iconic site becoming part of their St Patrick's Day celebrations cannot be overstated.

Niagara Falls was first lit in 2012 after discussions between Tourism Ireland and the Niagara Parks. The format has remained the same ever since, with both the American and Canadian Horseshoe Falls bathed in green for 15-minute intervals at the top of the hour from 9pm to 1pm. Since 2017, LED lights have added a sublime intensity to the whole experience as well as dramatically reducing total energy consumption.

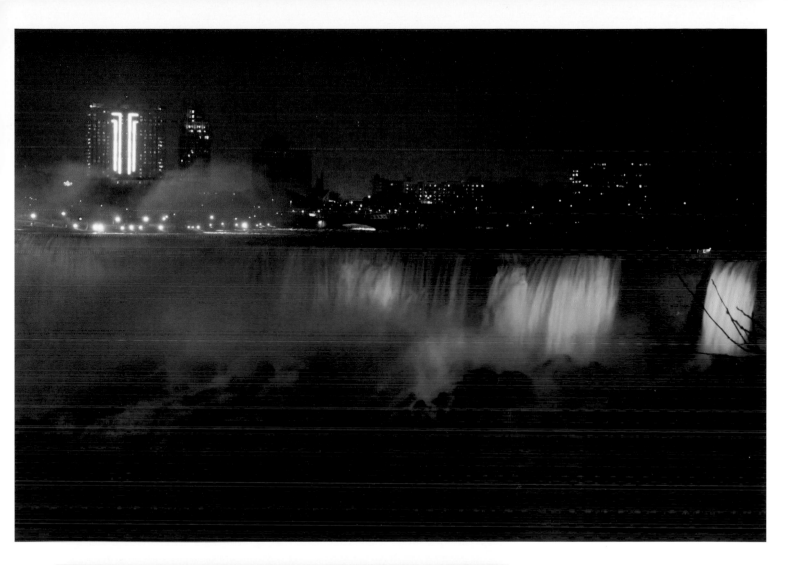

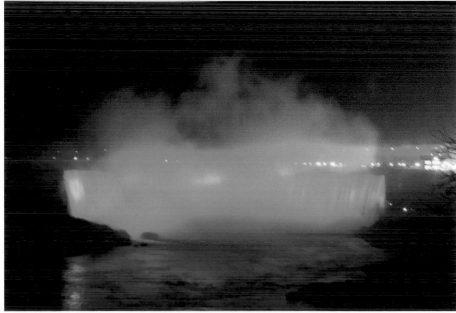

Burgtheater Vienna, Austria

As far back as 1756, an entertainment dedicated to St Patrick was hosted by the Imperial Court in Vienna, attended by descendants of the 'Wild Geese' – the Irish soldiers who left Ireland for continental Europe after King William III defeated King James II.

Thanks to a small but very active Irish community, and the support of the Irish Embassy, St Patrick's Day is still celebrated in Vienna all these centuries later.

The Viennese greenings began with the Burgtheater, one of the magnificent historic buildings that line the Ringstrasse Boulevard. Completed in 1888, it is renowned as the finest German-language theatre in the world. Its beautiful façade, featuring busts of playwrights and famous figures from the literary world, was first greened on St Patrick's Day 2012 to the accompaniment of a lone Irish piper.

The 8,000 onlookers also enjoyed Irish music and dancing, and Irish food and drink served from a tent outside the theatre.

The greening had been arranged by the Irish Embassy, in collaboration with the department responsible for city affairs based at the UN HQ in Vienna. The St Patrick's Day weekend begins with a parade through the city that starts at a 12th-century monastery founded by Irish monks, where a special St Patrick's Day Mass is held.

The parade features dancers of all ages from the local Irish dance academies, brass bands and pipers, an army of leprechauns, and packs of wolfhounds and Irish setters adorned with green hats and Austrian and Irish flags.

Selfridges Department Stores, London and Birmingham, UK

The greening of the Selfridges flagship store in Oxford Street, London – the world's busiest shopping thoroughfare – was something of a coup in these early days of the Global Greenings campaign. After the equally famous Harrods in nearby Knightsbridge, the store is the largest in the UK and attracts visitors from around the world.

Tourism Ireland, whose London offices are to be found within the building, were particularly grateful to Paul Kelly, Managing Director of Selfridges, for making it happen.

As well as Oxford Street, the architecturally renowned Birmingham branch went green for the day.

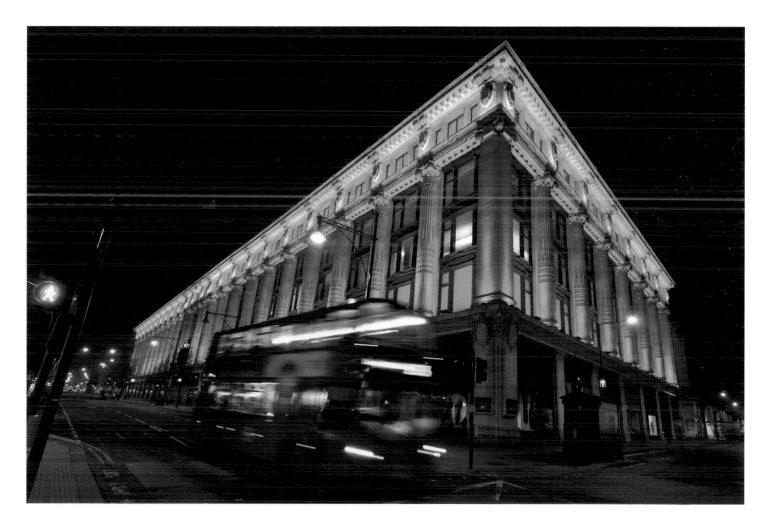

The Armadillo, Glasgow, UK

The Clyde Auditorium, an events venue seating 2,000 people, was built back in 2000. It was soon nicknamed 'the Armadillo' as it looks so like a giant version of that leathery creature from the Americas. In fact the building is meant to signify an interlocking series of ships' hulls – a reference to the Clyde's shipbuilding legacy – and has been compared to the Sydney Opera House.

First greened in 2012, its 2013 greening also included building work on its sister in the Scottish Events Campus, the SSE Hydro building. The completed Hydro was included in a joint greening with the Armadillo in 2014.

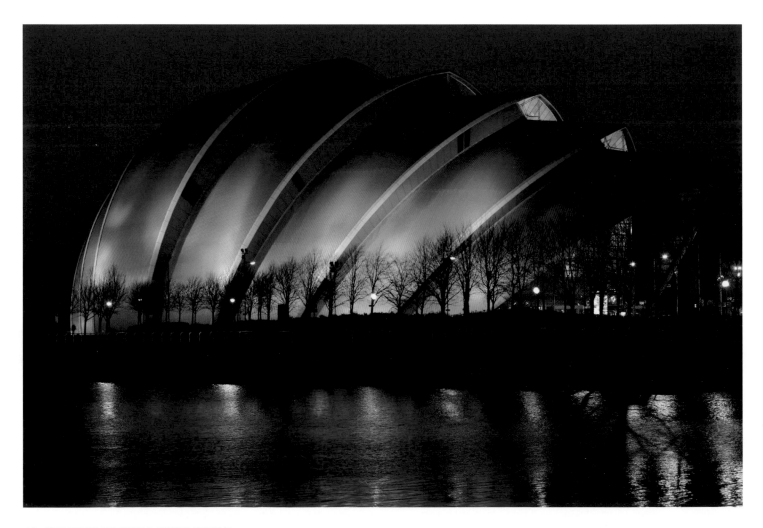

Municipal Stadium, Poznań, Poland

The Poznań stadium, used by Polish soccer club Lech Poznań, has an important connection to Ireland, so a greening here seemed an obvious idea. The stadium was one of the venues for the group stages of Euro 2012 and, fittingly, these games included the Republic of Ireland against both Croatia and Italy.

Recently reconstructed, it is now the county's fifth-largest stadium, with a capacity of just over 43,000. It is known for its distinctive white roof.

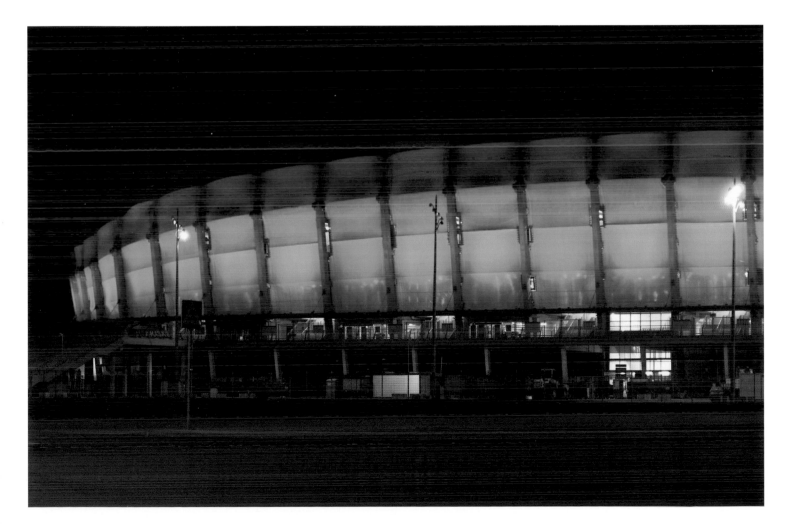

The Sheep of the Pyramids, Bathgate, Scotland

They've turned blue for St Andrew's Day and red just to brighten things up, but the 'Bathgate flock' saved their finest performance art for St Patrick's Day 2012, when their owner dyed them green. The flock live on a land sculpture called 'the Pyramids' alongside the M8 at Bathgate, between Edinburgh and Glasgow. The sculpture was created by artist Patricia Leighton in 1993 and consists of seven 11 metre (36 feet) high ramps made of earth. The grazing sheep keep the grass down!

There was no cost involved but the proud owner was given a crate of whiskey for his participation – Irish, we presume!

Cibeles Fountain, Madrid, Spain

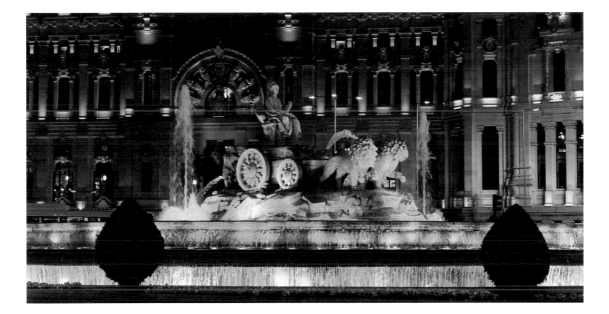

When Real Madrid football fans want to celebrate their victories, they head for their spiritual home, the Cibeles Fountain in the heart of the city. Built in 1782, it stands in the centre of the Plaza de Cibeles and is surrounded by some impressive palaces. Designed as a source of water for the local houses, the fountain portrays Cybele, the Roman goddess of fertility and agriculture, on a chariot drawn by two lions.

Barbara Wood of Tourism Ireland Spain remembers being delighted when national television station E1 came to view the greening and interview her live. She was slightly perturbed, however, when the green light enveloped the famous fountain five minutes early — until she discovered that this had been arranged by the TV crew, anxious to show the greening before the credits!

Then Minister for Tourism Leo Varadkar and Niall Gibbons, CEO of Tourism Ireland

2013

The Diaspora Takes Up the Green Torch

In 2012, Irish student Ben Finnegan had introduced the idea of the expat-inspired greening. Encouraged, other members of the vast Irish global diaspora took up the challenge. The results were extraordinary.

Thanks to a collaboration initiated by an Irish expat in the city, Irish visitors to Las Vegas for St Patrick's Day were thrilled to see the iconic 'Welcome to Fantastic Las Vegas' sign lit in green. In Germany the magnificent Allianz Stadium in Munich, home to Bayern Munich, was added thanks to an Irish woman with an influential role in Allianz's German offices.

The unique spread of that diaspora, with the Irish love of travel that stretches back millennia, uncovered extraordinary and often moving links still celebrated by expats and locals alike. One of the most spectacular greenings of all, of the *Christ the Redeemer* statue in Rio de Janeiro, has a heartwarming Irish story as its source.

Würzburg in Bavaria has the earliest known connection between Ireland and Germany – its ancient Neumünster Church owes its existence to Irish monk St Kilian. It just had to go green!

On a more intimate scale, the *Little Mermaid* in Copenhagen was able to join the fun thanks to a dedicated expat, while Canada's most famous Italian chef not only greened his moustache but changed his name for the day!

The Allianz Arena, Munich, Germany

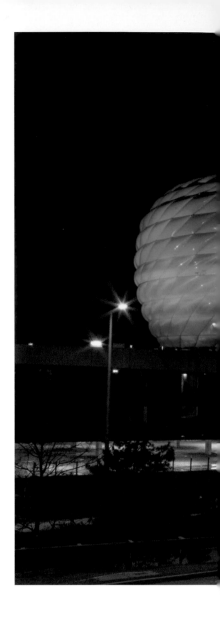

When the magnificent 75,000-seater Allianz Arena was first illuminated in green, on St Patrick's Day 2013, locals were stopped in their tracks. It was the first time that the iconic stadium had been lit up to celebrate a non-footballing event, and the effect was spectacular. It wasn't, however, quite as simple as it looked.

At this point the stadium hadn't yet been converted to LED lighting. What in later years could be achieved by the flick of a switch needed a massive lighting system to be rigged up to hold the endless rows of green bulbs that would reflect onto one side of the stadium (in later greenings, the entire stadium has been bathed in green). Setting up and dismantling this elaborate system was a major technical achievement.

It couldn't have been achieved without the enthusiastic response from the Allianz Stadium owners, Bayern Munich, and, of course, Allianz themselves. It took a little longer to convince the authorities that a sudden infusion of green over the city wouldn't lead to disruption on the roads (a motorway overlooks the stadium).

That it happened in the first place, and continues to be such a popular event in the city, says much about the warmth of Irish–German relations and the global popularity of Ireland's patron saint. Although it doesn't have the same scale of Irish diaspora as cities in the UK or US, Munich hosts the largest St Patrick's Day parade in mainland Europe, largely celebrated by Germans themselves.

Encouraged by the many popular Irish pubs in the country– the first point of contact with Ireland for many Germans – an enormous wellspring of goodwill exists for all things Irish there. There is also a very supportive network of Irish businesses and Irish–German associations who help spread the word. After all, if locals didn't understand why their biggest stadium was turning green, there would be little point to the greening!

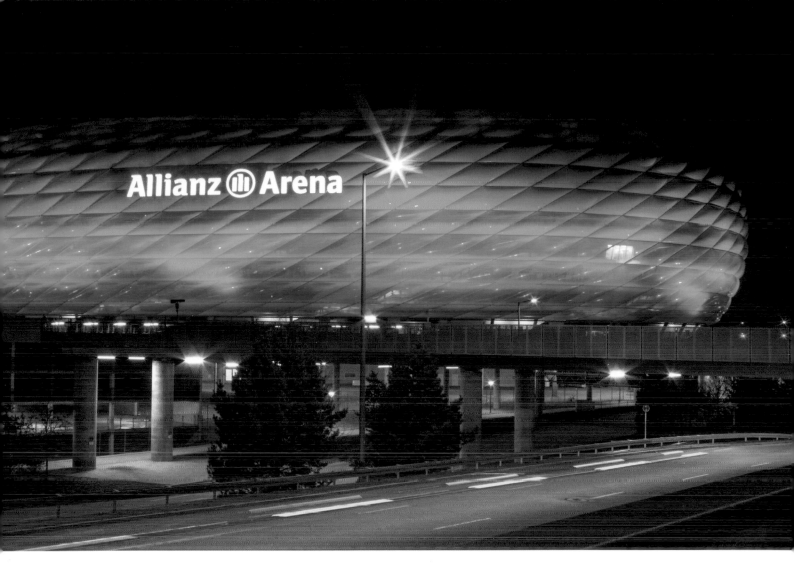

The Irish diaspora played a vital part in the greening of the Allianz Arena. When the idea was mooted, Denise Quinn of Tourism Ireland in Germany recalled that a key member of Allianz in Munich was Irish. She got in contact with Sinead Browne (now Chief Regions and Markets Officer, Allianz Global Corporate and Specialty), who knew the right people to talk to at the company.

'There was no need for me to convince anyone in Allianz,' Sinead says. 'It placed the Allianz Arena with other iconic buildings around the world and fitted in perfectly with Allianz's global profile. It was a fantastic event, with the then ambassador, Dan Mulhall, and his wife attending. The feedback was wonderful and it has become a much-loved Munich tradition. Although I recently returned to London, I am proud to see that the stadium recently followed our lead, celebrating Gay Pride with rainbow colours.'

Neumünster Church, Würzburg, Germany

The huge number of countries that have joined the Global Greenings campaign owes much to the vast Irish diaspora, whose remarkable growth began in the 18th century.

Some greenings, however, have their roots in a far earlier generation of Irish travellers – none more so than the Franconian city of Würzburg, which was visited in 686BC by the Irish monk St Kilian in the earliest recorded connection between Germany and Ireland.

St Kilian had already converted Duke Gosbert, the pagan ruler of the area, to Christianity when he informed him that he must separate from his wife, Gailana, as she was the widow of his brother. Perhaps unsurprisingly, Gailana took exception to this demand, waiting until her husband was absent before having Kilian and his comrades beheaded.

A few decades later, the first bishop of Würzburg built a church on the site where their remains were found, which would become known as Neumünster church. These remains are still kept in a shrine there, while their skulls are in the main altar of adjacent St Kilian's Cathedral.

A popular medieval pilgrimage to St Kilian of Würzburg would have attracted many Irish travellers to the region. Over the next few centuries Würzburg hosted several Irish monasteries, which provided accommodation for pilgrims travelling to the Holy Land or Rome. The 8th-century Letters of St Paul and the St Kilian's Gospel, held in Würzburg University Library, are the oldest surviving examples of written Irish language in the world.

So, when Tourism Ireland discussed the idea of a greening, the local German–Irish Association, chaired by Matthias Fleckenstein, was delighted, seeing it as the perfect way to highlight the city's unique Irish heritage. The city itself is extremely supportive, taking care of the technical side of the lighting.

Every St Patrick's Day the evening begins with a short prayer service in the crypt of the now greened Neumünster church. Another greening, that of the Town Hall, also takes place, to mark the 1999 twinning of Würzburg with the town of Bray and the county of Wicklow in Ireland.

HMS *Belfast*, London, UK

In the year the G8 Summit came to County Fermanagh, the profile of Northern Ireland suddenly went global. So it seemed entirely fitting to feature the most famous London landmark associated with Northern Ireland – HMS *Belfast* – in the Gobal Greening campaign of 2013.

Believe it or not, the illustrious ship had actually been launched on St Patrick's Day, in 1938. The largest warship yet built at Belfast's world-famous shipbuilders Harland & Wolff, she played a vital role in the war effort, protecting Atlantic conveys and helping launch the Allied bombardment during the 1944 invasion of Nazi-occupied France.

Now moored on the Thames as a 'museum ship' and one of London's leading tourist attractions, the cruiser is owned by the Imperial War Museum, which was delighted to highlight its Northern Irish connection with a particularly memorable greening.

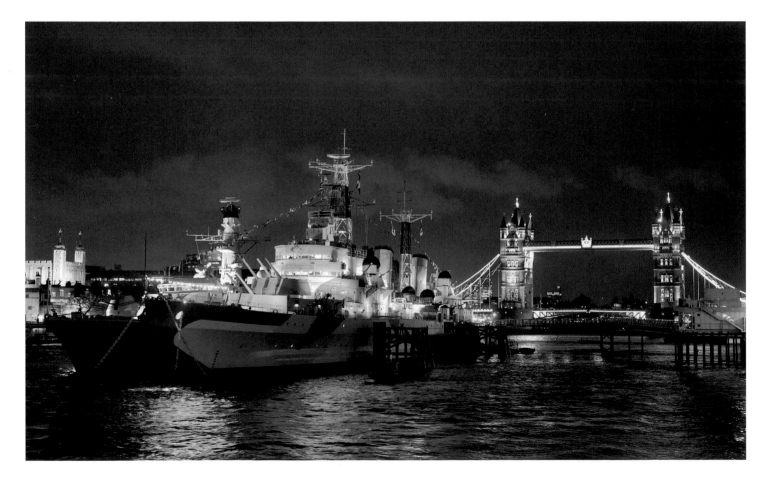

Anfield Stadium, Liverpool, UK

The impact of The Gathering, a tourism-led initiative to mobilise the huge Irish diaspora to return to Ireland for a year of special events, was huge. The Gathering didn't just have an impact on Ireland – all those with Irish connections around the world felt connected.

Nowhere more than Liverpool, the first city for so many Irish emigrants for so many centuries. And when you think of Liverpool, one of the first images that comes to mind is Anfield Stadium, home to Liverpool Football Club (sorry, Everton fans!).

So, on St Patrick's Day 2013, the year of The Gathering, many gathered for a Liverpudlian tribute to Ireland – the greening of Anfield.

The Little Mermaid, Copenhagen, Denmark

The first-ever greening in Denmark certainly made a splash. The Little Mermaid, the famous bronze statue by Edvard Eriksen on Copenhagen's Langelinie promenade, has been a popular attraction since 1913, but it would be another century before it first turned green.

This greening was the idea of Irish expat Siobhán Kelleher-Petersen, who first contacted then Minister for Tourism Leo Varadkar. He directed her to Tourism Ireland in Copenhagen, and soon the City Council and the Copenhagen Tourist Board were involved too.

That was the easy bit. Siobhán discovered that the statue is actually under copyright – tightly guarded by Eriksen's family – and such requests are usually frowned upon.

Undeterred, Siobhán got in contact with Eriksen's granddaughter Alice to seek permission, and a solution was quickly found. Since 2001, Siobhán has been organising a St Patrick's Day three-legged race in Copenhagen, which supports charities in Denmark, Ireland and Cambodia. If this were to be a fundraising event for the charity, the family were happy to give it the green light.

At 7pm on Saturday 16 March, a green light illuminated Denmark's most famous mermaid and the city's St Patrick's Day celebrations were off to a mighty start. A tent with a bar had been erected near the statue, while over 200 revellers enjoyed some cracking Irish music and dance and contributed hugely to the fundraising for the charity race.

This drawing of the mermaid is by Siobhán's New York-based friend Áine Keogh, and was used to promote the event

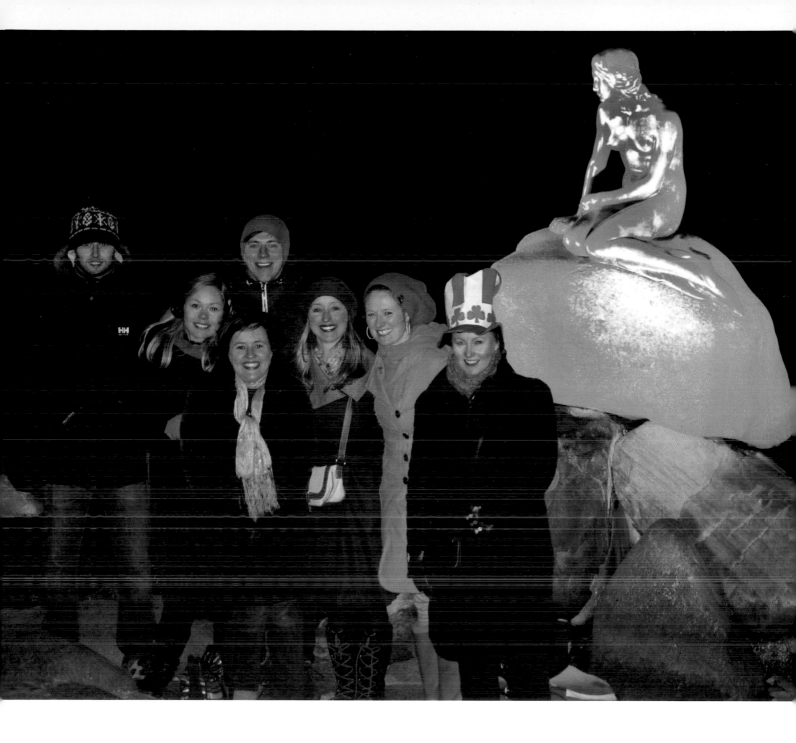

'Welcome to Fabulous Las Vegas' Sign, USA

Since 1959, the neon 'Welcome to Fabulous Las Vegas' sign has been a symbol of the city of glitz, glamour and gambling, and today it's the go-to place for visitors to take selfies. So when Tourism Ireland, the Irish consulate and the Las Vegas Convention and Visitors Authority (LVCVA) were considering the ultimate location for the first greening in the Nevada city, it was the obvious choice.

So keen are they to be part of the global St Patrick's Day celebrations that LVCVA have since added several other major greenings, including the amazing High Roller at the LINQ, 550 feet above the central strip – the world's tallest big wheel – and famous hotel/casinos like the Palazzo and the Venetian.

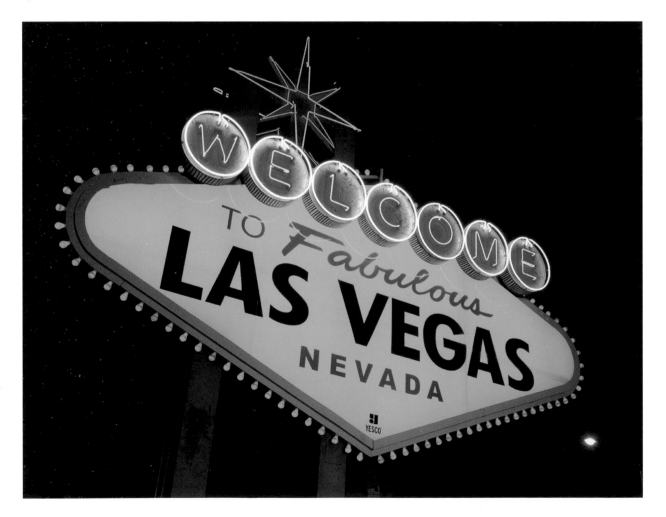

The Tower of Hercules, A Coruña, Spain

Some greenings almost choose themselves! How could you find a better candidate than the Tower of Hercules in A Coruña, a popular holiday destination in the Spanish region of Galicia? The UNESCO World Heritage-listed lighthouse is actually the only Roman lighthouse still in use today. And according to one legend associated with the tower, it played a large part in creating Ireland!

That story claims that it was built by the mythical Celtic king of Galicia, Breogan. According to the *Leabhar Ghabhála Érenn*, the 11th century 'Book of Invasions', Breogan's son Ith decided to investigate the green land he had seen from the tower. To aid his passage, Breogan lit a bonfire at the top of the tower. Although Ith was killed, his nephew Mil went on to conquer Ireland, his descendants becoming the ancestors of the Gaels.

And so, to celebrate St Patrick, a green light shone for the first time on the Tower of Hercules, and the close connection between the Celts of Ireland and ancient Galicia was royally celebrated!

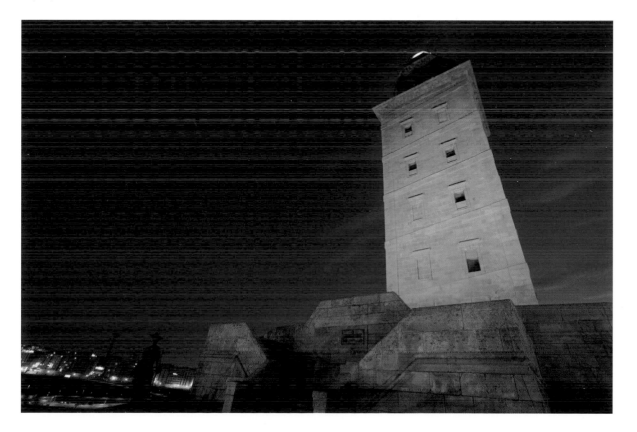

The Greening of Chef Massimo Capra's Moustache, Toronto, Canada

The *Christ the Redeemer* statue, Niagara Falls, the Pyramids of Giza – the Global Greenings have captured many spectacular landmarks in Irish green. But more modest celebrations can still be memorable, as proved by the famous greening of Chef Capra's moustache on St Patrick's Weekend 2013.

Massimo Capra – or O'Capra, as Canada's most famous Italian chef chose to be called for the day – had two reasons for his demonstration of solidarity with St Patrick. First of all, having worked with Tourism Ireland on several projects, he wanted to help its 'Great Green Off' campaign, which invited people from around the world to share their greening photos or videos on Facebook.

But Chef O'Capra also wished to celebrate the ancient Celtic roots of his hometown, Cremona in northern Italy. Certainly his green moustache got plenty of publicity, including an appearance on a TV breakfast programme and several newspaper articles.

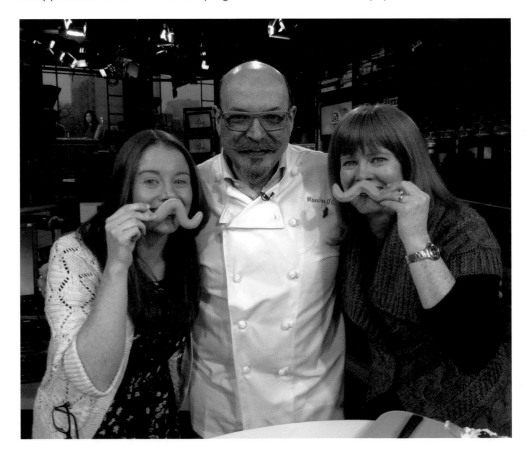

Richard Branson's Beard

There are few parts of the world that the Irish diaspora doesn't reach. Take the greening of Richard Branson's beard, for instance. The story begins outside Twickenham on St Patrick's Day 2012, where 20,000 green hands had just lit up the rugby stadium at the England versus Ireland game. Sure, Ireland had lost, but the party was starting nevertheless when Richard Branson decided to join the Tourism Ireland team for a photo shoot.

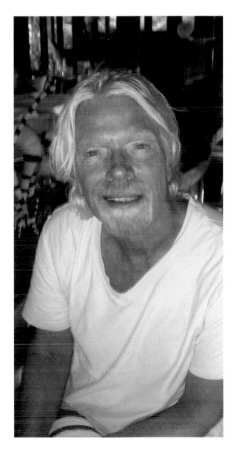

Caroline Mulligan of Tourism Ireland Scotland sent the photo to her colleague from the London Tourism Ireland team, Suzanne Morris, whose husband worked for the head of the Virgin empire in the Virgin islands, where the family now lived. Could Suzanne see if her husband's boss, who had already been so supportive of Ireland and lived nearby, could go green himself for the big day? Richard Branson was more than happy to oblige, and had his photo taken with Suzanne's children Libby and Jack and two of their friends.

With a Twitter following of over three million, Branson's message to the Irish alone put the greenings on the global map for the year. It reflected the changing mood since the first impact of the economic recession: 'It's great to see Ireland getting back on its feet again and outperforming many other nations affected by the global financial crisis. I look forward to visiting your beautiful country again very soon.'

It is said that the tweet even got a like from the US president, who would later become affectionately known in Ireland as Barack O'Bama!

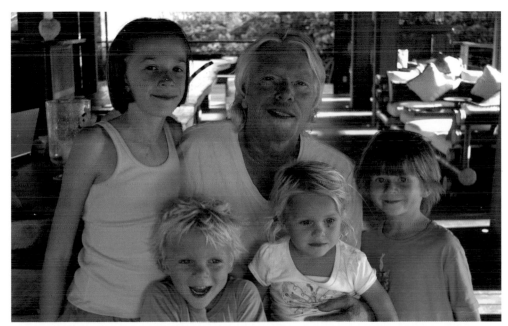

(left to right) Libby Morris, Theo Jones, Richard Branson, Zara Jones and Jack Morris

Bad Homburg Castle, Germany

Not all greenings turn out quite as planned, but sometimes the most difficult ones bring the most fulfilment! That's what Jan O. Deiters and his partner, Anna, residents of Bad Homburg in Germany, discovered back in March 2013.

Jan is a writer, journalist and musician who has specialised in travel articles and books on Ireland. For six years he published the German-language print magazine *Irland Edition* (now online). Over time he developed close contacts with Tourism Ireland in nearby Frankfurt, and when he learned of the greening concept he knew he had the ideal location.

One of Germany's most impressive castles, the Schloss (castle) at Bad Homburg, has an ancient white tower which has become the symbol of this lovely spa town. So determined were Jan and Anna to create this memorable greening that they financed it themselves.

They arranged for a lighting company to install some huge spotlights, as well as hundreds of metres of power lines, on 16 March, ready for the next day. That night, as the work was under way, the heavens opened – torrential rain followed by heavy snow. It will be all right, they told themselves; it will clear by tomorrow – we can rely on the 'luck of the Irish'!

Sadly, St Patrick's Day was just as bad. The castle courtyard was flooded with 15 cm of water and Jan and his team were left soaked, frozen and frustrated. Although it was one of the most beautiful greenings yet, not a single visitor risked the extreme weather for a glimpse of the 'Green Tower'.

That wasn't the end of the story, though. Jan's photos of the greening were shared with the rest of the world via the live website of the Global Greenings 2013 campaign.

The next day, of course, the castle was bathed in glorious sunshine. So much for the 'luck of the Irish'!

Vilnius Bell Tower, Vilnius Old Town, Lithuania

This famous bell tower was a perfect candidate for a greening. The distinctive tower looms high over the magnificent 18th-century Vilnius Cathedral, in Cathedral Square – a gathering place for the people of Vilnius since pre-Christian times.

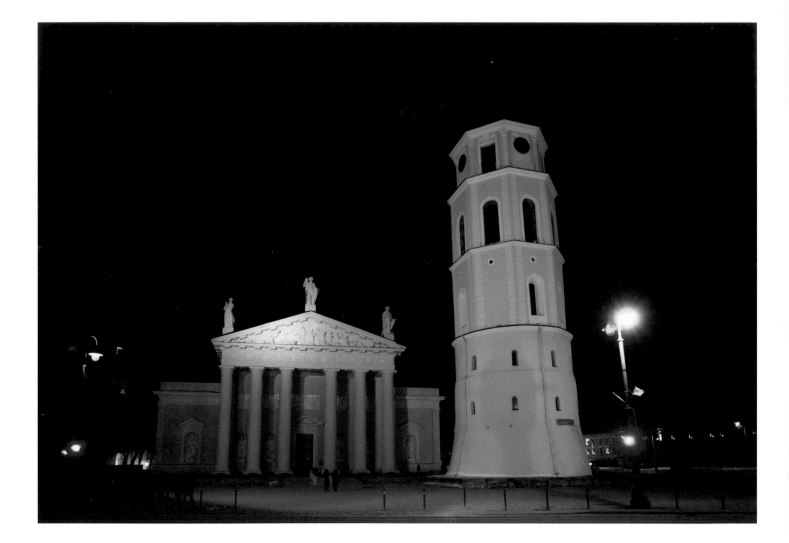

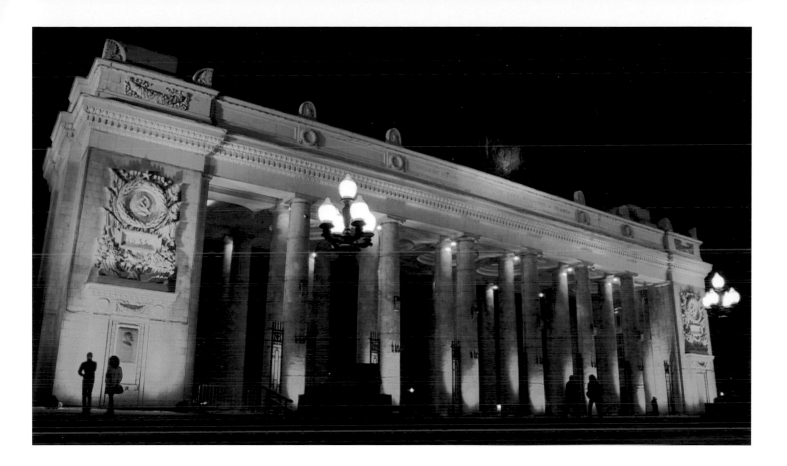

Gorky Park Gateway, Moscow, Russia

A popular gathering place for Muscovites since the 1920s, Gorky Park was named after the writer Maxim Gorky. It achieved fame in the west with a novel and film of the same name starring William Hurt and Lee Marvin. The greening this year was of its famous gateway.

Kingdom Centre Tower, Riyadh, Saudi Arabia

To be the fifth tallest skyscraper in Saudi Arabia (at time of writing) is quite a claim these days. The views from its Sky Bridge are one of the highlights of a visit to Riyadh. Stretching 65 metres in length, this 300 tonne steel structure sits on top of the 300 metre Kingdom Tower and allows visitors views of the entire city following a speedy trip up on one of two elevators.

The view of the stunning skyscraper, which hosts a shopping mall, hotel and apartments, is always remarkable, but on St Patrick's Day, as the darkness gathered, the now green skyscraper was a truly spectacular sight.

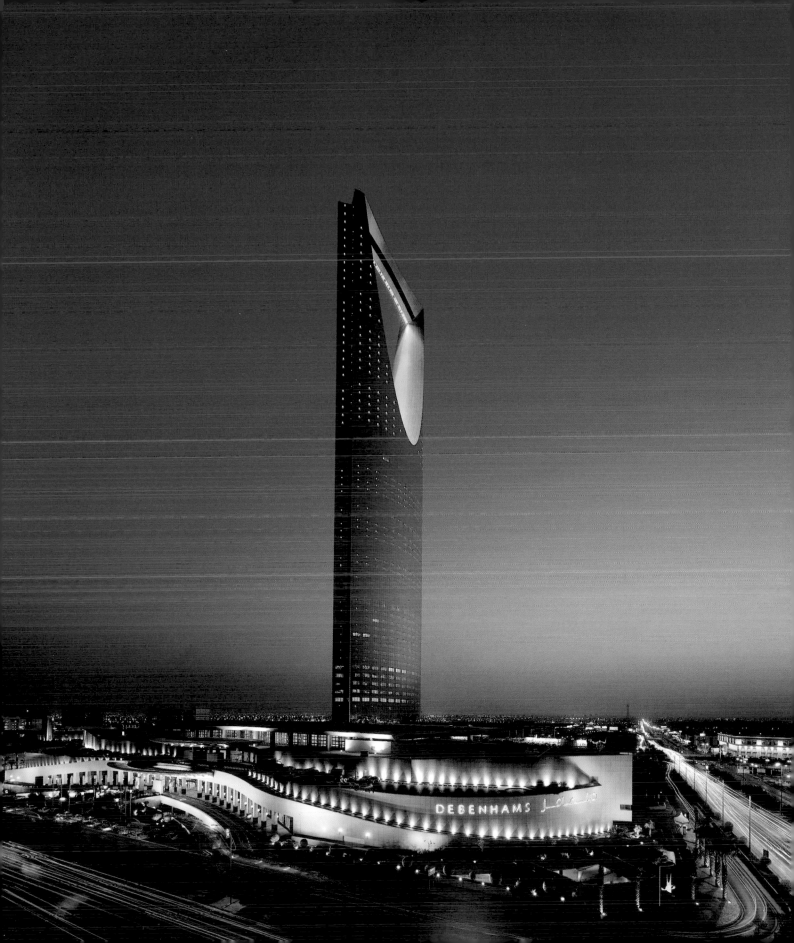

Christ The Redeemer Statue, Rio de Janiero

The world offers few more breathtaking sights. Arms stretched wide, the *Christ the Redeemer* statue stands high on a mountain rising from a rainforest, 700 metres over Rio de Janeiro. Now listed among the New Seven Wonders of the World, it looks down protectively at a city of over 12 million people and its famous sights – the Maracanã football stadium, the meandering harbour and Copacabana Beach. Completed in 1931, the 38 metre high art-deco statue has become a symbol not just of its city and country, but of Christianity itself.

To arrange a greening of such an illustrious landmark would not be an easy task. But with the long history of Irish immigration to South America and the dedicated work of Irish missionaries among its people, not least in Rio, if anyone had a chance it was the Irish.

Building on years of excellent diplomatic relations, the Irish Embassy team broached the idea with the Catholic Church, owners of the statue. Eventually word came through that the idea had been approved by the Archbishop of Rio, Dom Orani João Tempesta. The first the world knew of the good news was during a visit by President Michael D. Higgins and his wife, Sabina, in October 2012, following a meeting with the Archbishop.

Finally the day arrived and, as darkness fell, the Archbishop was present to see Deputy First Minister of Northern Ireland Martin McGuinness switch the lights on to create one of the most spectacular greenings of all.

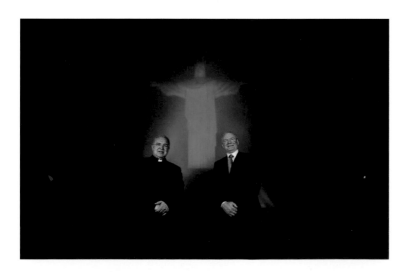

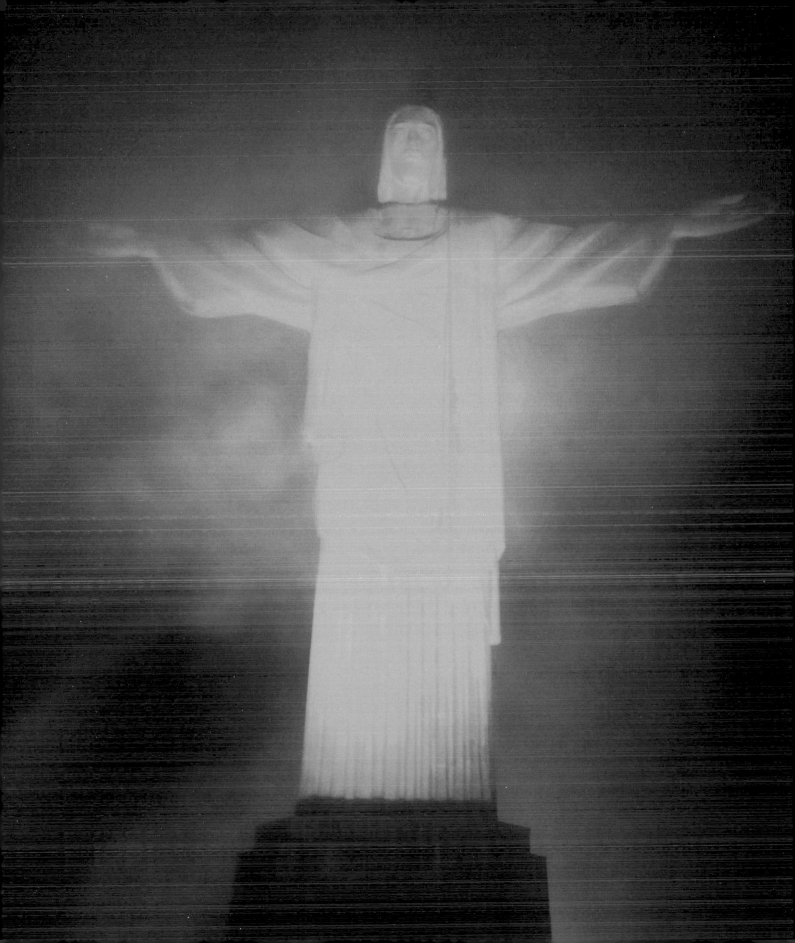

The Sphinx and Pyramids, Giza, Egypt

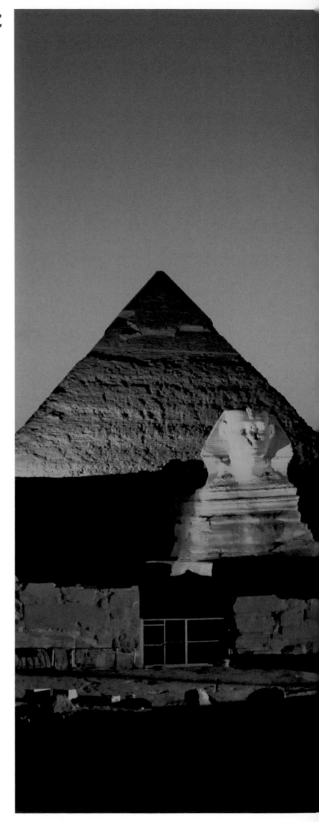

There will always be debate as to what is the most extraordinary greening of all. From the Colosseum in Rome to the Great Wall of China, there is no shortage of candidates, but turning the last surviving Ancient Wonder of the World green in 2013 had a global impact that few locations could surpass. The Sphinx and Pyramids (including that ancient wonder, the Great Pyramid) are just four miles south of Egypt's capital, Cairo, on the west bank of the River Nile. Dating from 2500BC, they dominate the Giza Plateau and have become the symbol of Egypt itself.

To green such an iconic representation of the ancient world was a major coup for the Global Greenings and was the result of a collaboration of Matt McNulty, former Director General of Bord Fáilte and then Ambassador of Ireland to Egypt Isolde Moylan with the Egyptian Ministry of Culture and Ministry of Antiquities.

It was no easy task logistically to bathe such a huge landmark in green, with the sensitivity demanded by such a historic and important landmark. But for all who witnessed this greening, and the millions who viewed it on social media, it was a spectacular and awe-inspiring sight!

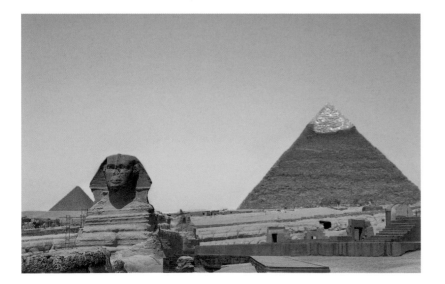

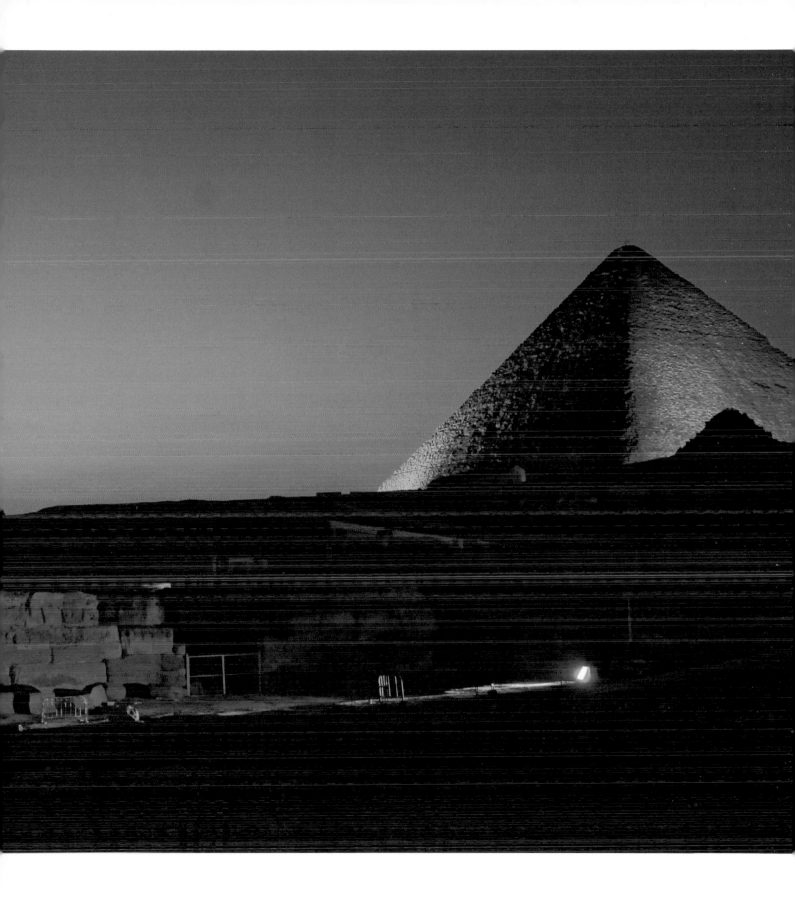

Gateway of India, Mumbai

Down by the waterside in Mumbai, the magnificent Gateway of India is one of the country's most famous landmarks. Sometimes referred to as the 'Taj Mahal of Mumbai', it is the city's leading visitor attraction. So, when Ambassador of Ireland to India Feilim McLaughlin was talking to local authorities about an inaugural greening in the country, it was the perfect choice.

The monument had been built to commemorate the visit of King George V and Queen Mary to the city (then called Bombay) in 1911. It stands next to the pier from which they disembarked. It took several years to plan and build the monument, which didn't open until 1923. Perhaps its most significant event was when the First Battalion of the Somerset Light Infantry passed through the Gateway in 1948, in a ceremony that commemorated the end of British rule and the birth of an independent India.

The greening was heralded by a colourful media event that evening, which included Indian dancers wearing green saris to celebrate the coming together of Indian and Irish cultures.

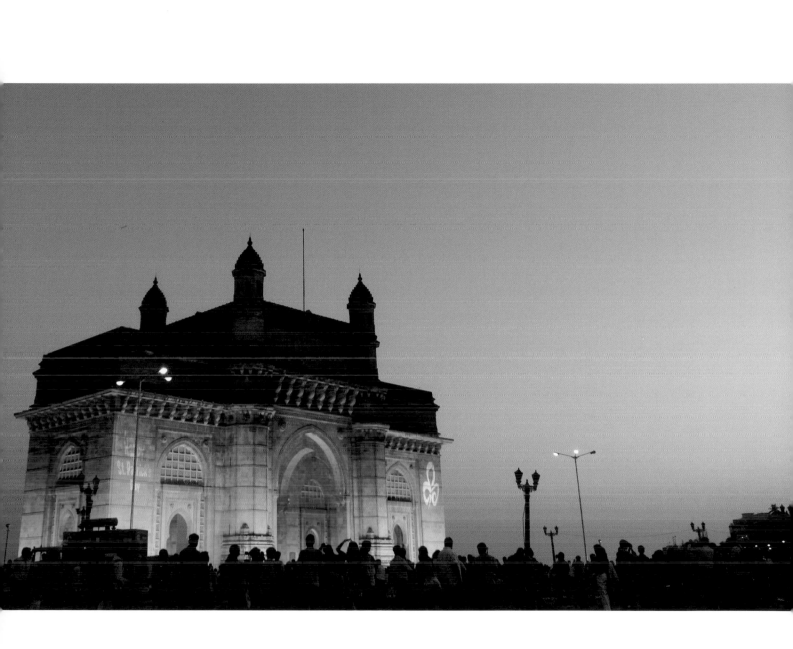

Other Greenings Around the World, 2013

Pacific Science Center, Seattle, USA

Canton Tower in Guangzhou

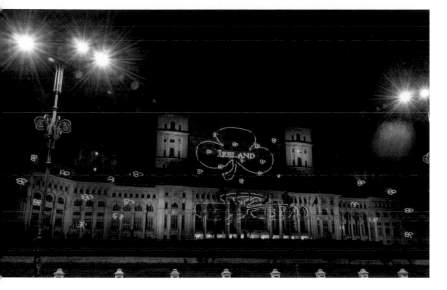

Palace of Parliament, Bucharest, Romania

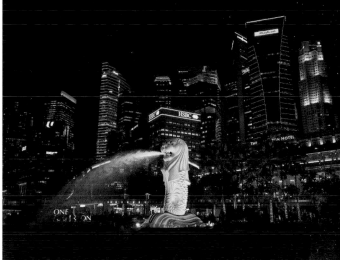

Merlion Statue, Singapore

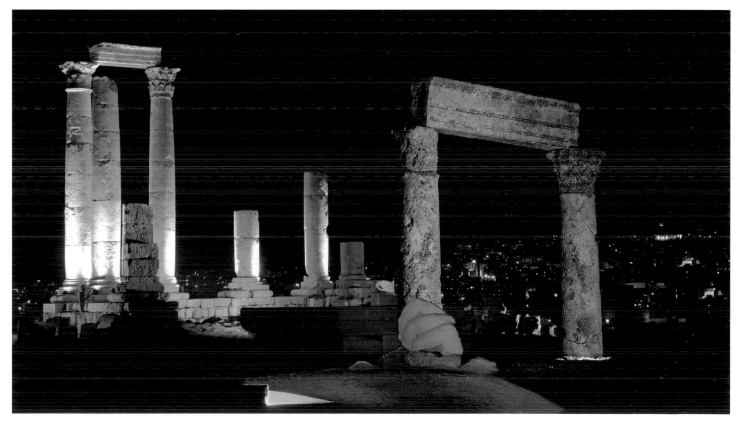

Temple of Hercules, Amman, Jordan

Riverdance meets South African dancers – the meeting of two famous dancing cultures, celebrated in green

2014

Landmarks – Big and Small

A greening can be awe-inspiring or intimate, and it can celebrate any field of endeavour.

As the numbers continued to grow into 2014, greenings took place on every scale. And it wasn't just the spectacular landmarks that caught the public imagination. One of the more modest but successful attention-grabbers happened when four Tourism Ireland UK colleagues snuck out in the early hours to recreate the famous zebra-crossing cover of the Beatles' *Abbey Road* album. Equally compelling were the cancan dancers of the Moulin Rouge doubling up with Irish Riverdancers to celebrate St Patrick's Day outside the 'Moulin Vert'.

In a way, Scott's Antarctic Base was both great and small, but nothing could be bigger than the Great Wall of China, which represented an extraordinary coup for the Global Greenings project.

Elsewhere, the Ambassador of Ireland to France joined Mickey and Co. at Disneyland Paris for the greening of Sleeping Beauty's Castle, while onlookers were mesmerised by the green spray at Europe's largest waterfall, the Rhine Falls in Switzerland.

In terms of iconic status, few locations can match the great Ferris Wheel of Vienna, immortalised by Orson Welles' Harry Lime in *The Third Man*. In the southern US city of Savannah, which holds the world's third-biggest St Patrick's Day Parade, fountains turned green for decades; now the magnificent town hall was added to the Greening campaign.

Several sporting greenings were introduced – at Soldier Field, Chicago; Whistler ski resort in Canada; and the vast Holmenkollen Ski Jump in Oslo, Norway.

Abbey Road, London, UK

Long before the city awoke on 14 March, four members of the Tourism Ireland team in London had been busy – impersonating The Beatles! Developing an idea by one of the team, Sofia Hansson, they emerged at the famous zebra crossing outside the Abbey Road Studios in north-west London at first light – a brief window to avoid traffic.

Placing pre-cut pieces of Astro-Turf on the white areas of the crossing, they marched across like the Fab Four on the cover of their *Abbey Road* album. One member of the team even insisted on carrying his cigarette like George Harrison. Photos and info went to a PR agency and several newspapers, and soon went viral!

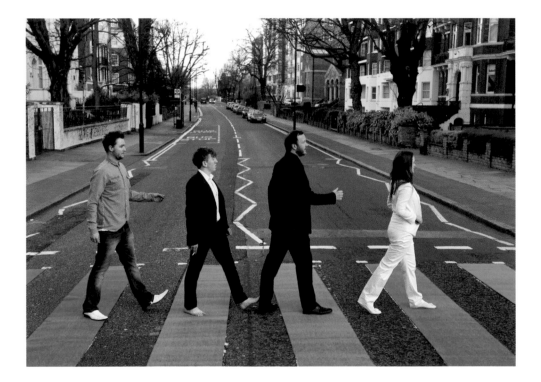

Sleeping Beauty Castle, Disneyland Paris, France

Mickey and Minnie Mouse in Irish costumes mingling with guests including the Ambassador of Ireland to France, Chip 'n' Dale copying moves from *Riverdance*, visitors dancing to Celtic music, and a spectacular firework display over a fairytale castle – it can only be St Patrick's Day at Disneyland Paris!

The greening of the Sleeping Beauty Castle has been part of St Patrick's Day festivities there since the early days, but in 2014 there was a very visible innovation when a huge white version of the Tourism Ireland logo was projected onto the green castle.

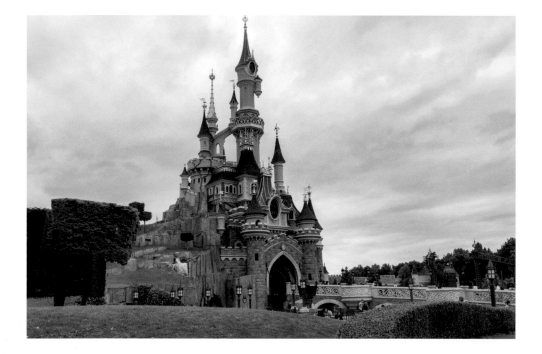

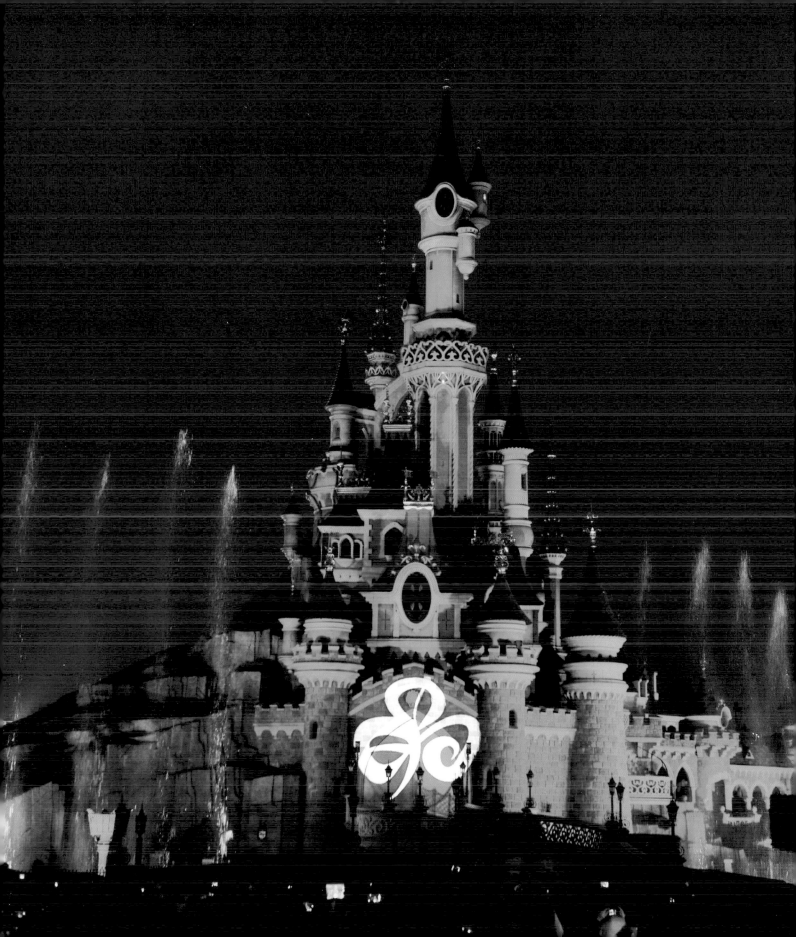

The Rhine Falls, Neuhausen am Rheinfall, Switzerland

the spray fell thickly on us, as standing on it and looking up, we saw wave, and rock, and cloud, and the clear heavens through its glittering ever-moving veil. This was a new sight, exceeding anything I had ever before seen. (Mary Shelley, author of *Frankenstein,* on her visit to the Rhine Falls, 1840)

Imagine Mary, if you had seen it green!

176 years after Mary Shelley was wowed by the largest waterfall in Europe, Tourism Ireland Switzerland engineered one of the most spectacular greenings yet.

The world-famous Rhine Falls, one of Switzerland's main attractions, are located on the High Rhine near the town of Neuhausen am Rheinfall, about an hour's train ride from Zurich. Over 150 metres (490 feet) wide and 23 metres (75 feet) high, they are an awesome sight.

While locals and visitors looked over the gushing waterfall as it turned green, from viewing platforms on both sides of the Rhine, lucky visitors to the Tourism Ireland event had a bird's-eye view from the riverside restaurant, Schlössli Wörth. Arriving in time for the 7pm switch-on (the greening lasted the whole St Patrick's Day weekend), they went out to the Falls on a boat, specially greened for the occasion, disembarking on the stone at the bottom. Then it was back to the restaurant for a hearty Irish meal and live Irish music.

So far, this has been Switzerland's only greening, repeated each year. But surely its magnificence will inspire many more!

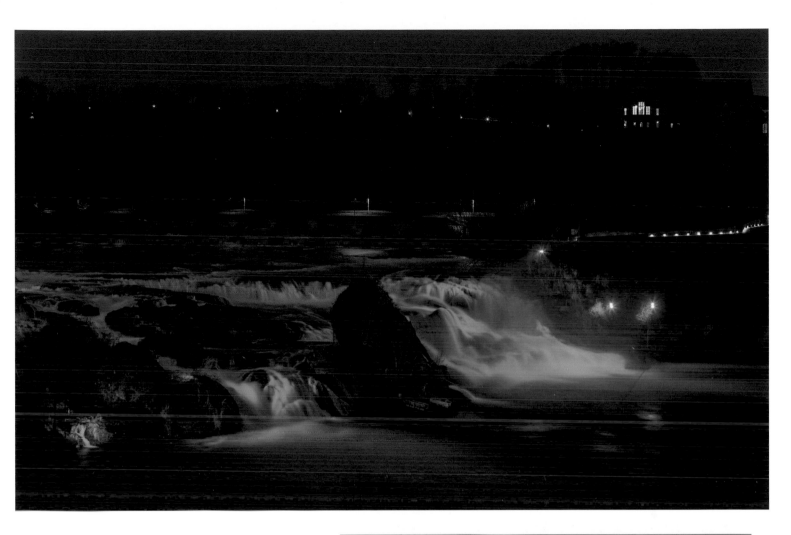

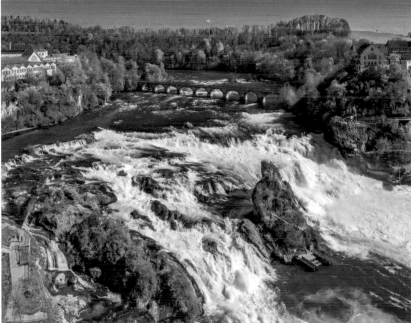

Giant Ferris Wheel (Wiener Riesenrad), Vienna, Austria

What film lover could forget the importance of the Wiener Riesenrad to the atmospheric wartime thriller *The Third Man*, where on-the-run crook Harry Lime, played by Orson Welles, finally meets up with his one-time friend and now pursuer, Holly Martins (Joseph Cotten)? The two look down from the height of the world-famous Ferris wheel on wartime Vienna in one of the best-loved scenes in cinematic history.

Clearly the famous big wheel had great potential for a greening, but how could such a coup be engineered? Unusually for such an iconic landmark, the Wiener Riesenrad is privately owned and, by a huge slice of luck, co-owner Peter Petritsch turned out to be a huge fan of Ireland, which he regularly visits to play golf. Delighted for the wheel to be part of the St Patrick's Day weekend, he even offered a free cabin for Tourism Ireland to hold its pre-greening media event. Over 30 journalists attended, and, as they spread the word, few people in the city were unaware of what was coming.

For this first greening – the Wiener Riesenrad has been greened most years since – Peter even offered an added incentive: free admittance for anyone named Patrick. Unfortunately, we don't have a record of how many Viennese Patricks emerged that day!

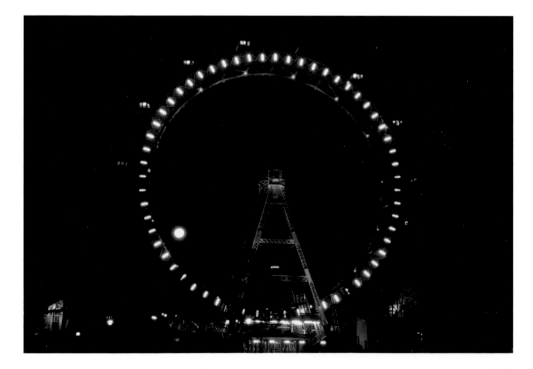

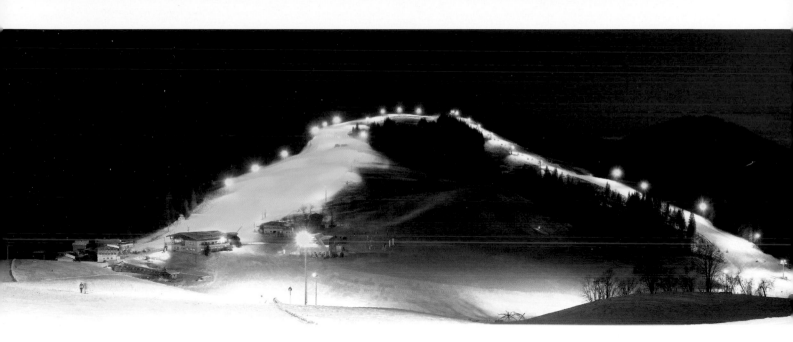

Skiwelt Soll (Ski Resort), Austria

Not only is this Tyrolean ski resort famous for the beauty of its panoramic views, it's become the place to go for lovers of après-ski at its best – lots of cool bars, traditional Tyrolean inns and fabulous food. In short, a great place for a party.

It's not surprising, then, that it attracts so many Irish visitors each season. Actually that was a primary reason for this unique greening, as the owners of the resort wanted to attract more end-of-season visitors and 17 March was perfect timing.

They certainly did St Patrick proud, turning an entire ski slope green for skiers to enjoy a unique experience. As they reached the bottom of the piste there was the added reward of Irish music, green beer and all the ingredients of a great party!

Kaprun Castle, Austria

Just over an hour's drive from Salzburg, 12th-century Kaprun Castle towers over the town whose name it bears. Thanks to its love of the party spirit, this stunning ski resort is an enthusiastic participant in St Patrick's Day celebrations each March. The castle is the focus of the town's cultural events.

Under the title 'The burg [castle] goes Irish!', there's Irish food and drink, whiskeys and beers, green Irish cocktails, Irish folk music and line dancing. And to add to the Irish feel, the castle's courtyard is turned green.

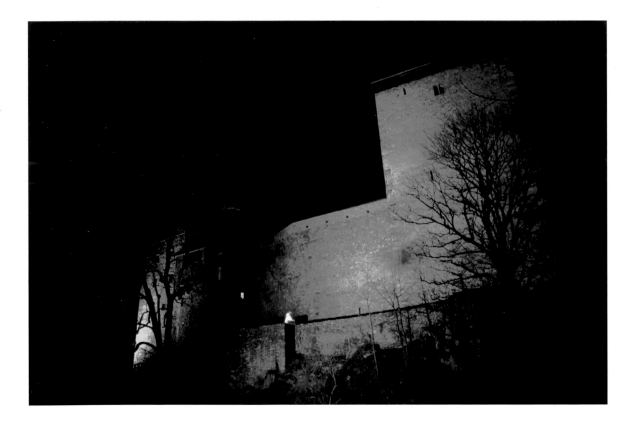

Savannah Town Hall, USA

Each 17 March, the historic seaside city of Savannah, Georgia hosts the second-largest St Patrick's Day Parade in the US, after New York. Perhaps that seems odd given that Savannah's Irish community is so small, but for the duration of the festivities everyone in the city considers themselves Irish!

Over this time more than 300,000 people, twice the city's population, enjoy all kinds of fun. Stalls selling Irish-themed gifts and food line City Market and River Street as bands play live throughout the city and the bars are packed with revellers.

One of the festival's oldest traditions begins when the St Patrick's Day Parade Grand Marshal pours green dye into the famous fountain in Forsyth Park. Soon every single fountain in Savannah will be green. But in 2014, the St Patrick's Day greening in Savannah took on a new meaning – the City Hall joined the Global Greenings movement, with lights shining beneath its imposing 21 metre (70 feet) dome.

How does this small city come to host the world's third-largest St Patrick's Day Parade? Back in 1812 the Hibernians Society of Savannah was formed to help needy Irish immigrants; the first St Patrick's Day Parade, a very modest affair, was held the next year. The first public procession was held in 1824 and numbers grew each year, especially after the great wave of Irish immigration following the Great Hunger of the 1840s.

Tourism Minister Leo Varadkar (left) with Paul Gleeson, Consul General of Ireland in Atlanta, in front of the 'greened' City Hall in Savannah, Georgia

Soldier Field Stadium, Chicago, USA

Home to the Chicago Bears football team, Soldier Field is one of the most famous stadiums in American sport. It was a great coup when the owners of the stadium allowed the distinctive columns at one side of it to be greened in 2014.

Although both Tourism Ireland and the Irish Embassy are constantly involved in encouraging greenings around the US, Chicago needs little persuading. Seeing itself as the number one city for St Patrick's Day in the US, it is proactive in keeping that status alive. Its ever-increasing number of greenings include high-profile locations like Navy Pier, the John Hancock Center, the Wrigley Building, the Civic Opera House and Trump International Hotel & Tower.

A key driver of the city's greenings is the ShamROCK Chicago Council, a group of businesses and civic leaders representing Chicago's many Irish organisations.

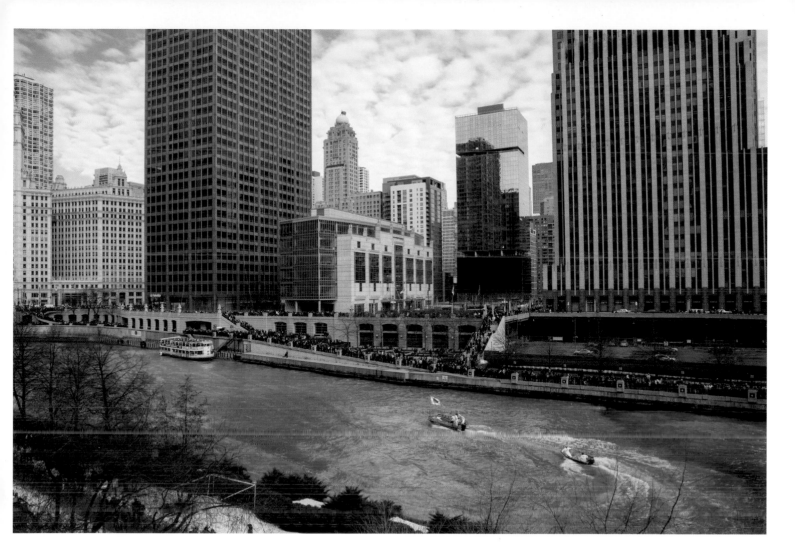

Even before the greenings Chicago deserved a special mention, thanks to the green river that runs through it every 17 March. That tradition goes back all the way to 1962 and a man called Stephen Bailey, who was not only chairman of the city's St Patrick's Day parade, but part of a local plumbers' union. For some years a green dye had been used to detect pollution and leaks in the Chicago River. Noticing the colour on a colleague's overalls after he had been pouring the dye – the ideal shade of green – Bailey had his inspiration. Why not turn the entire river green every 17 March?

Now using a vegetable dye, the process begins early in the morning of the Saturday nearest 17 March, when the parade is held. It takes 45 minutes for the river to turn green and about five hours for the dye to disperse. By then over 400,000 revellers will have cheered the greening of the Chicago River. But don't ask for the formula used in the dye – it is one of America's most closely guarded secrets!

Whistler, Canada

Considered the top ski resort in North America, Whistler is no stranger to St Patrick's Day. About 120 kilometres (75 miles) north of Vancouver, British Columbia, Canada, its buzzing après-ski life is more than familiar with the Irish *craic*.

But the festivities took on an added dimension on 17 March 2014 when the resort went green for the first time to celebrate St Patrick's Day. That included greening the lights at the Village Gate Boulevard Inukshuk and the Town Plaza Gazebo. The following year they added the covered bridge over Fitzsimmons Creek.

As for the celebrations, visiting skiers were quick to get into the Irish party spirit at venues like the Dubh Linn Gate pub and the Garibaldi Lift Company lounge bar, where revellers can enjoy themselves while watching skiers hurtle downhill.

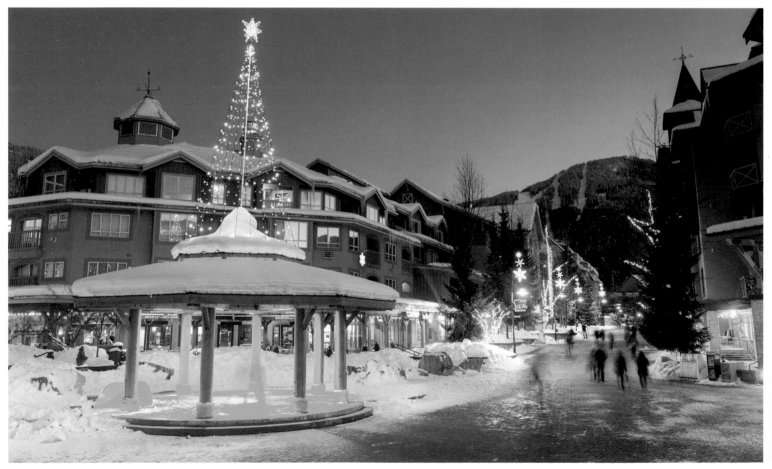

Holmenkollen Ski Jump, Oslo, Norway

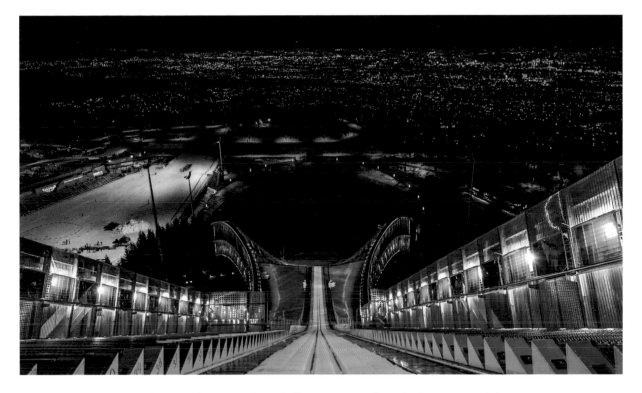

The heart of Norway's skiing traditions, Holmenkollen, just outside Oslo, hosts one of the world's most spectacular ski jumps. Rising some 60 metres in the air and made out of 1,000 tonnes of steel, this state-of-the-art jump is visible even from the city centre. With seating for thousands of spectators, it regularly hosts some of the world's most prestigious ski-jumping competitions.

No wonder then that Ambassador of Ireland Angela O'Farrell and her colleagues were anxious to add Holmenkollen to the growing roster of prestigious greenings around the world. The Mayor of Oslo and the Director of the Holmenkollen Ski Museum were delighted to get involved.

Funding for the installation of green filters required for the lighting was supplied by Tourism Ireland and sponsors Suretank and Smurfit Kappa, Irish companies operating in Norway.

On 12 March a week of St Patrick's festivities was launched when the Irish Minister of State for Horticulture, Forestry and Food Safety, Tom Hayes, attended the greening.

After a St Patrick's Day reception held in the famous Ski Museum, adjacent to the jump, the greening ceremony was held in the Royal Tribune, the box used by the Norwegian Royal family, which has a fantastic view of the jump.

Cabot Tower, St John's, Newfoundland, Canada

Dominating the skyline of one of North America's oldest cities and overlooking the entrance to St John's harbour, Signal Hill is a spectacular site for a greening. It is also a very apt one. St John's, the capital city of Newfoundland, was home to hundreds of Irish fishermen as long ago as 1680 and also has a more recent connection with Ireland.

In 1901, four years after the late-Gothic revival Cabot Tower was commissioned to commemorate the 400th anniversary of John Cabot's discovery of Newfoundland, Guglielmo Marconi set up the first transatlantic wireless signal here. Just three years previously, Marconi – the son of a member of Ireland's Jameson whiskey dynasty – had pioneered this work on Rathlin Island, Co. Antrim. St John's Irish connection is celebrated by its twinning with Waterford.

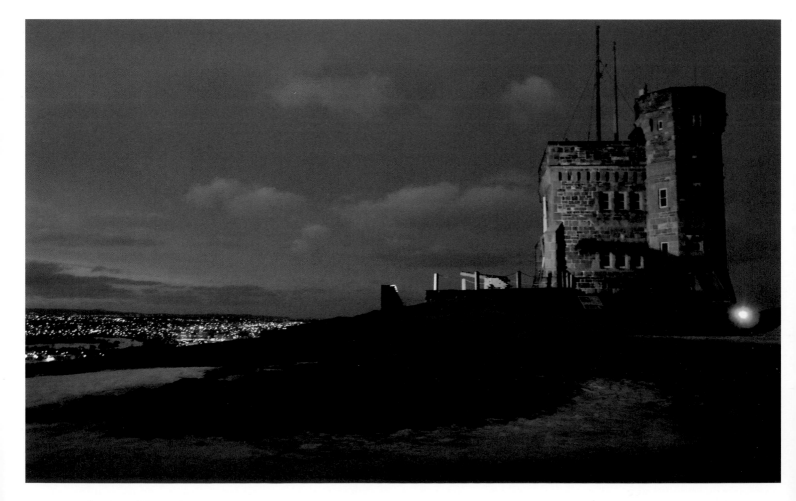

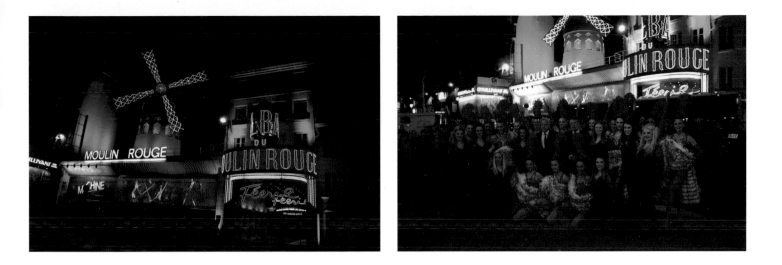

Moulin Rouge, Paris, France

When the Moulin Rouge first turned green in 2011, the famous cancan dancers turned on a special show for St Patrick's Day. In 2014, they were joined by members of Ireland's own dancing royalty, the *Riverdance* troupe.

As the Moulin Rouge became the 'Moulin Vert' again, the Riverdancers began the celebrations, followed by the cancan dancers. Brian O'Driscoll had just inspired the Irish rugby team to victory against France in Paris; thus Ireland won the Six Nations Trophy in O'Driscoll's last international match. Now France and Ireland combined to put a smile on the world's face.

The Great Wall of China

For the past six St Patrick's Days, the Great Wall of China – one of the most iconic edifices on earth and ostensibly the only man-made one that is visible from space – has 'gone green'.

How did this come about? In autumn 2013, shortly after I took up my assignment as Ireland's Ambassador to China, I initiated feelers with the Chinese authorities as to whether they would agree to illuminate in green a well-known segment of the Great Wall at Badaling, close to Beijing.

Shortly before the 2014 St Patrick's Day Festival, we received word from the Chinese side that the greening of the Great Wall could go ahead more or less as requested. We were all overjoyed.

At midnight, a long section of the wall was formally illuminated by the visiting Irish Minister, Brendan Howlin. Everyone present was hugely impressed by the sight of the Wall going green, one segment after another. A celebratory imbibement was accompanied by live traditional Irish music, performed in the open air.

Images of the Great Wall of China going green for the first time ever flashed around the world. We could not be more appreciative of the extraordinary gesture on the part of China in greening its most iconic national site in honour of Ireland and her people.

Before I departed China in the summer of 2017, the Chinese authorities told us that China would be prepared to illuminate the Great Wall in green on each St Patrick's Day indefinitely into the future. We were all thrilled at this. It quickly became a symbol of friendship between Ireland and China and their respective peoples.

Paul Kavanagh, current Irish Ambassador to Japan

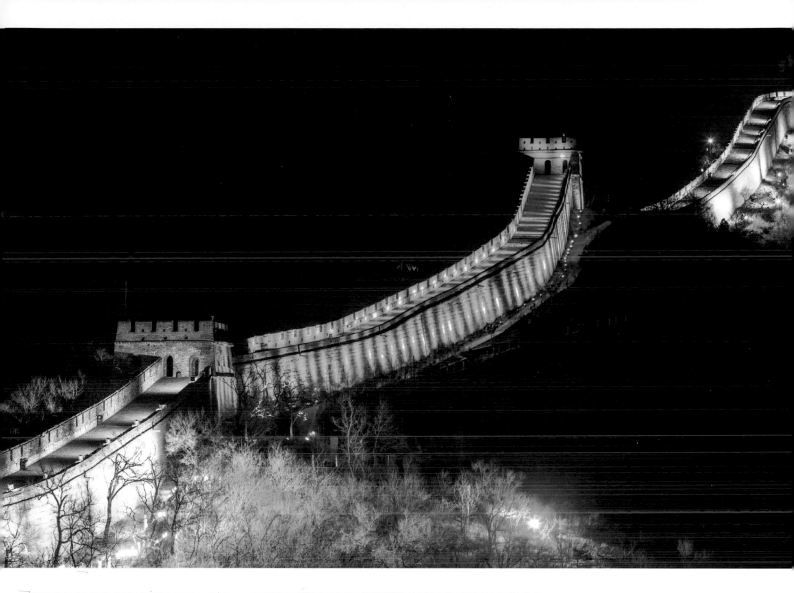

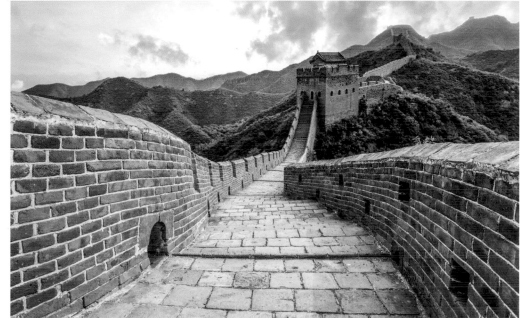

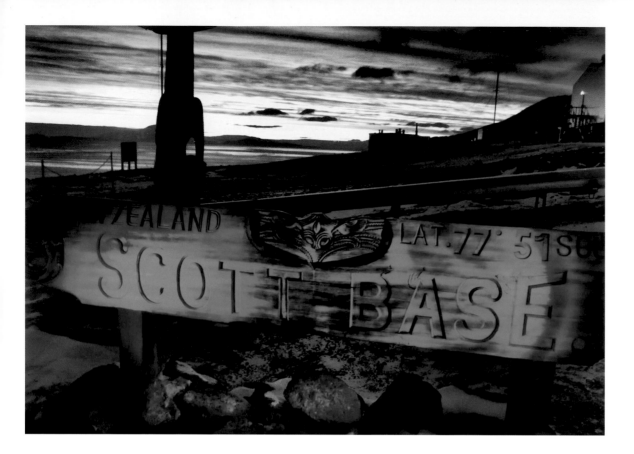

Scott Base, Ross Island, Antarctica

Four years after the first greening of the Sky Tower in
Auckland, another unique New Zealand effort saw the Scott
Base sign go green. Named after famous British explorer
Captain Robert Scott, the New Zealand Antarctic research
facility was greened in recognition of the contribution to
Antarctic exploration by such renowned Irishmen as
Shackleton and Crean.

Galileo Planetarium, Buenos Aires, Argentina

Known as Planetario, this magnificent planetarium's 20
metre semi-spherical dome has a reflective aluminium
covering that looks wonderful in green!

Seoul Tower, South Korea

Through the auspices of the embassy, the famous Seoul Tower turned green in 2014. A communication and observation tower on Namsan Mountain, it marks the second highest point in Seoul.

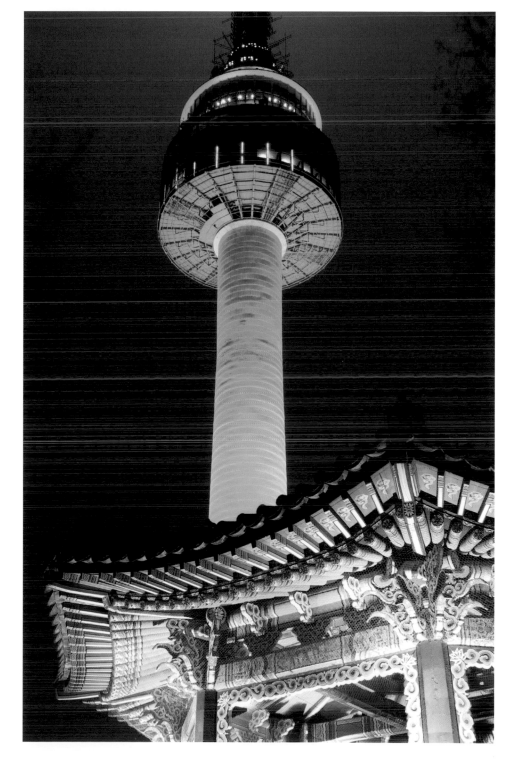

Other Greenings Around the World, 2014

Riverdance meets South African dancers

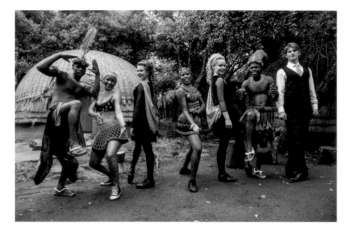

Irish Embassy, Paris

Grand Palace, Brussels, Belgium

Disneyworld, Orlando, Florida, USA

Hotel de Ville, Montreal, Canada

Ljubljana Castle, Ljubljana, Slovenia

City Hall, Houston, Texas, USA

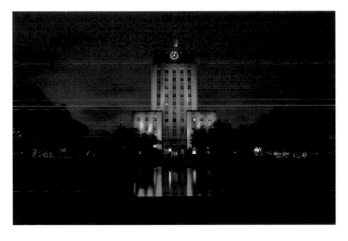

Derry~Londonderry, Clipper Race Yacht, moored at Quingdao, China

Museo Condes de Castro Guimãres, Caiscais, Portugal

Glasgow Prestwick Airport, Scotland

Rijksmuseum, Amsterdam, the Netherlands

2015

Ambassadors and Consulates

The greenings have largely been initiated by Tourism Ireland offices around the world and, increasingly, by members of Ireland's 70-million-strong diaspora. But there is another vital source – Ireland's global network of embassies and consulates. Not least of these, of course, was then Irish Consul in New Zealand Rodney Walshe, who originated the first, unofficial, greening with the Sky Tower in Auckland.

The diplomatic connections developed by successive Irish ambassadors and consuls have been crucial in identifying iconic locations and arranging for them to join the St Patrick's Day celebrations.

These had already included, for example, the Great Wall of China and the Burgtheater in Vienna. 2015 brought another wave of 'diplomatic' greenings, including the Colosseum, helped on its way by a glimpse of ancient Rome and a speech from Shakespeare!

Ambassador of Ireland to France Geraldine Byrne Nason was a huge influence in bringing about the greening at the spiritual heart of Paris, the Sacré-Cœur Basilica, which towers over the city. The Irish Embassy in Belgium was instrumental in greening Burg Square, part of the UNESCO World Heritage-listed historic centre of Bruges.

Cannes, France

Located on the hill of Suquet, the oldest part of Cannes, the 14th-century La Tour du Suquet dominates the picturesque old town. The tower was just one location in Cannes to be part of the Global Greening, largely due to its Mayor, David Lisnard, who was anxious to promote joint interests with Ireland's aerospace industry. He enthusiastically endorsed greenings right around Cannes, including the Town Hall, La Croisette, Palais des Festivals et des Congrès, and the famous Tapis Rouge Lumineux (red carpet).

For two months before the first greenings, local schoolchildren learned Irish music and songs to perform on St Patrick's Day while wearing special green shirts donated by Tourism Ireland. They were joined in the festivities by then Minister of Tourism Leo Varadkar. Cannes has been an enthusiastic supporter of the greenings ever since.

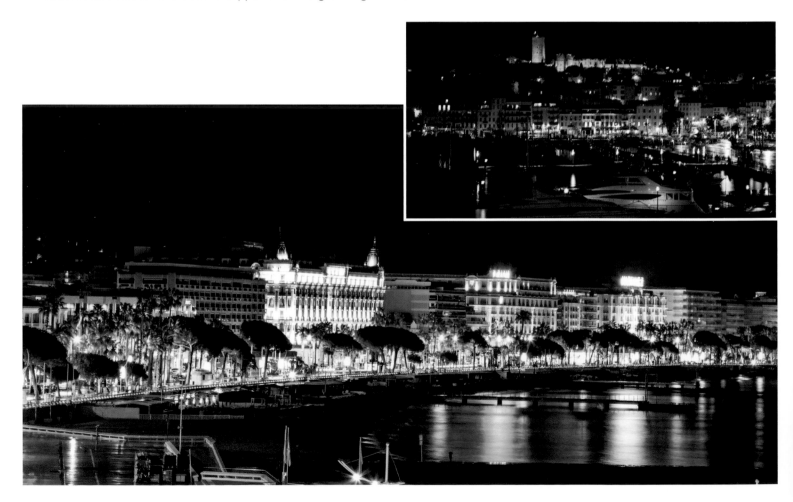

Hotel Negresco, Nice, France

Along with the multiple greenings in Cannes this year, St Patrick's sojourn in the south of France took in one of Europe's most beautiful hotels. The Hotel Negresco, located on the Promenade des Anglais in Nice, has been attracting the wealthy since opening in 1913. Named after the entrepreneur who built it, Henri Negresco, it is famous for its pink dome and the spectacular 16,309-crystal chandelier, originally commissioned by Czar Nicholas II, which dominates its Royal Lounge. Somehow its beautiful façade looks even better in green!

Sacré-Cœur, Paris, France

The Sacré-Cœur Basilica, towering over Paris in the famous Montmartre district, is the city's most recognisable building and one of the most visited tourist sites in Europe. To see its vast dome glowing green was an extraordinary spectacle, and made St Patrick's Day 2015 a very special experience for the thousands who thronged the area!

To arrange the greening, Irish Ambassador to France Geraldine Byrne Nason and her team met the Rector of the Sacré-Cœur, who fully embraced the spirit of the Greening initiative, as well as local authorities and the welcoming Mayor of the 18th district, who knew Ireland well and had happy Irish links. The greening developed into an annual party at the foot of the Basilica on the eve of St Patrick's Day. Irish music and dancing erupted on the steps, with visitors from across the globe mesmerised as the white Basilica became green.

Bamberg Town Hall, Germany

The Irish pub has always been a highlight of a visit to Ireland. In recent decades it's also become one of Ireland's greatest exports. Offering a welcoming ambience, Irish food and drink and, often, Irish music, these pubs have spread around the world, acting as a gateway to Ireland for many locals who first discover their affinity for all things Irish there. Needless to say, they have become a good source of greenings too.

The greening of Bamberg Town Hall was initiated by expat Ray Bradshaw, who then ran a pub called the Emerald Isle with his wife Orsi in the beautiful UNESCO World Heritage-listed medieval Franconian town. They had become friendly with Ambassador of Ireland to Germany Michael Collins, who, with his wife, attended an intensive two-week German language course four times a year in the town.

Ray had learned of the Greening campaign through his membership of the Irish Pub Association Germany, and when Michael suggested he try to arrange one in the town, Ray was delighted to take it on.

After discussing the idea with Tourism Ireland, the pair showed Bamberg Lord Mayor Andreas Starke images of previous greenings and a video of the Sydney Opera House the previous year. Seeing the huge publicity potential for Bamberg, Herr Starke suggested that the Town Hall would be ideal. Soon after the City of Bamberg came on board, sponsoring free Guinness on the day. With revellers enjoying the unseasonal great weather, St Patrick's Day was a massive success, with a Tourism Ireland stand outside the Town Hall attracting crowds.

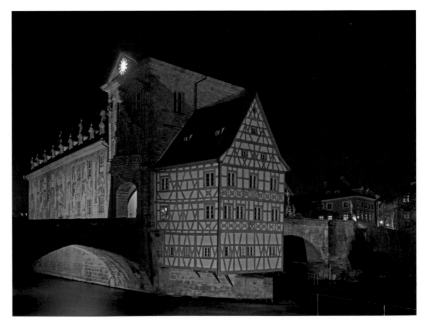

Ray and Orsi now run an Irish pub in the Franconian town of Grafenwöhr, which they are also hoping to put on the greening map.

Burg Town Hall, Bruges, Belgium

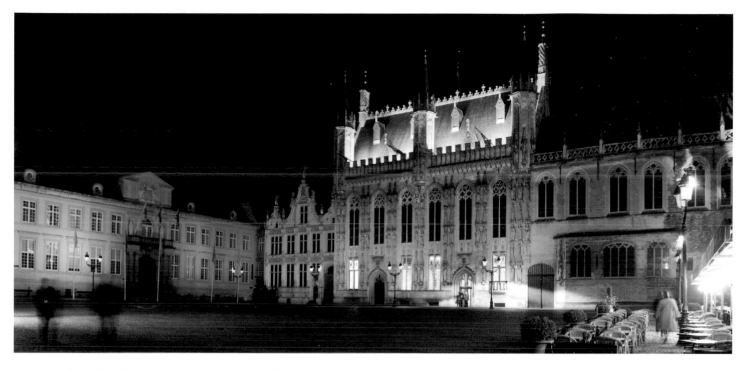

By 2015 the Global Greenings campaign had featured some of the world's most famous buildings and landmarks, from the Sydney Opera House to the Great Wall of China. This was a huge advantage in attracting other iconic sites. Such was the case with the greening of Burg Square, in the UNESCO World Heritage-listed historic centre of Bruges.

This greening was the result of a long partnership between the Irish Embassy and Danielle Neyts of Tourism Ireland Belgium in discussing the concept with mayors throughout the country, armed with a video of St Patrick's Day celebrations and the ever-growing list of prestigious greenings. In this case, large parts were played by Ambassador Eamonn Mac Aodha and the Mayor of Bruges, who was delighted that Burg Square would now be listed alongside some of the world's most famous landmarks.

The whole square was illuminated, including the Stadhuis, Bruges City Hall, the place of government for the city for more than 600 years. Built between 1376 and 1420, with its beautiful Gothic hall built in the 19th century, it is one of the most impressive buildings even in Bruges.

It was here that Danielle, Ambassador Mac Aodha and visiting Minister for European Affairs and Data Protection Dara Murphy attended a pre-lighting ceremony before mingling with the cheering crowd (including many locally based Irish students) as the ancient square was bathed in green.

The Colosseum, Rome, Italy

For when the noble Caesar saw him stab,
Ingratitude, more strong than traitors' arms,
Quite vanquished him: then burst his mighty heart;
And, in his mantle muffling up his face,
Even at the base of Pompey's statue,
Which all the while ran blood, great Caesar fell.

The annual greening of the Roman Colosseum had an unexpectedly Shakespearean origin. When the then Mayor of Rome, Ignazio Marino, invited then Ambassador of Ireland to Italy Bobby McDonagh to his office overlooking the Forum (and the very rostrum from which Mark Antony delivered his address at Caesar's funeral) to discuss a possible greening, he asked him to enjoy the view from his private balcony. The Irishman was so inspired by this glimpse of ancient Rome that he spontaneously broke into a recitation of Antony's eulogy.

The mayor, who turned out to bear a great affection for Ireland, was delighted. It was an inspired start to a great event and one that is now an annual part of the Italian greening, attracting huge crowds to this most famous reminder of the glory of ancient Rome.

It began on 16 March 2015 when Simon Coveney TD, then Minister for Agriculture, Food, Marine and Defence, had the honour of pressing the switch. Today it remains as popular as ever, part of a deep Roman appreciation of Ireland's patron saint. With cultural events, receptions and the strong Irish presence in Vatican City (Ireland has a separate ambassador to the Holy See), not to mention the arrival in the city of countless Irish visitors anxious to celebrate this special time in the 'Eternal City', Rome has become one of the great places to celebrate St Patrick's Day.

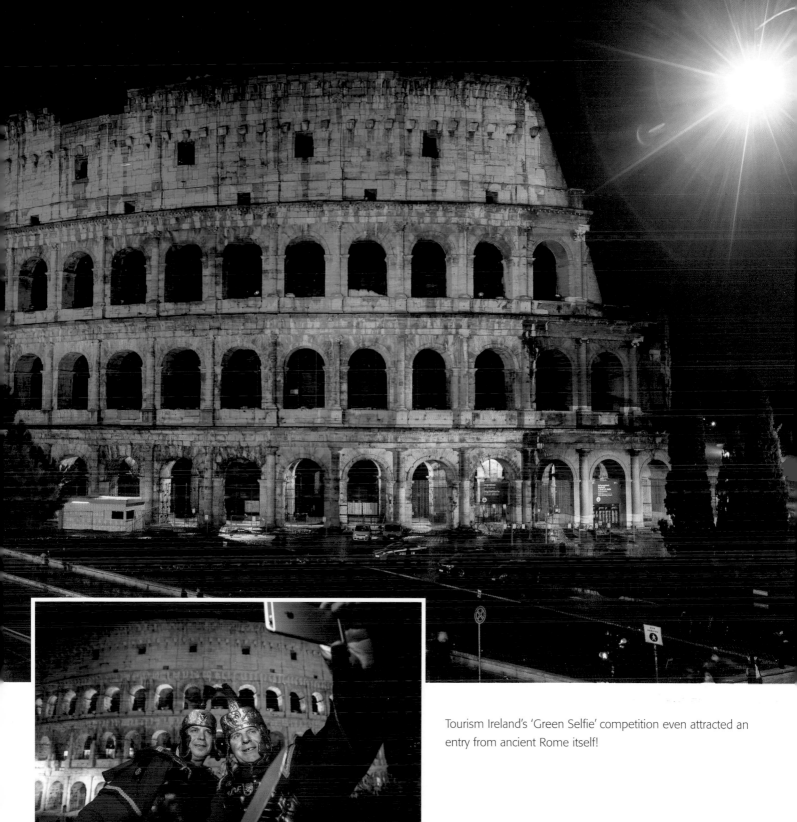

Tourism Ireland's 'Green Selfie' competition even attracted an entry from ancient Rome itself!

Iamsterdam Sign, Amsterdam, the Netherlands

When Tourism Ireland Netherlands were looking for an Amsterdam landmark that most clearly spelt out what the city was all about, they couldn't go past … well, Iamsterdam. More than two metres tall and 23.5 metres wide, the sign was located in a popular square behind the Rijksmuseum. It would be hard to find a higher profile landmark than the sign, which symbolised the city and had become its number one destination for selfies.

Tourism Ireland's Karen van der Horst, who had contacted former colleagues at Amsterdam Marketing to arrange the greening, had anticipated one potential objection. The colour of the Iamsterdam brand is red! But the prestige of becoming part of the Global Greenings campaign is now a great incentive – a message proudly relayed on Twitter and Facebook by Amsterdam City Council.

On the night itself, Tourism Ireland hosted a media event with over 40 journalists at a nearby restaurant, where a jury voted on the best articles on Ireland published in the Netherlands. Then it was out to watch as the light was switched on and Iamsterdam became 'weareireland' for a night.

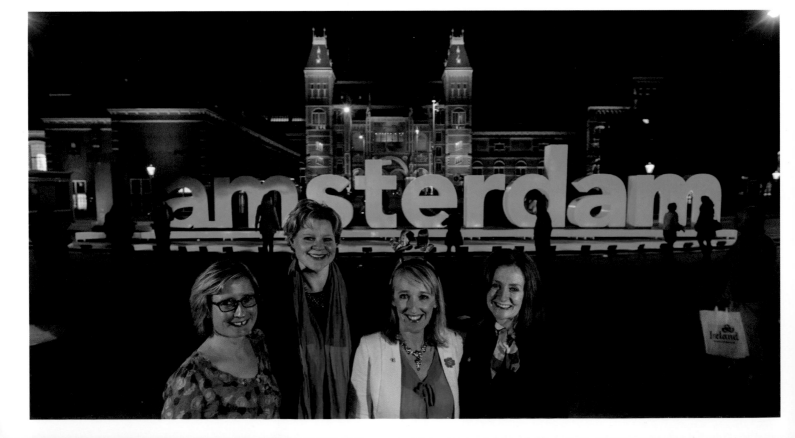

Reykjavik, Iceland

Sometimes greenings just come out of the air. When WOW air was launching a new route from Reykjavik to Dublin in 2015, they got in contact with Tourism Ireland's Nordic Markets to discuss ideas for publicity and were thrilled to hear about the Global Greenings campaign. Rikke Aagaard Petersen of Tourism Ireland, based in Copenhagen, said Tourism Iceland were delighted with WOW's input.

WOW got to work, with Tourism Ireland's encouragement, and arranged the greenings of several of Iceland's most prestigious landmarks. These included the spectacular tower of Hallgrímskirkja church, which can be seen from virtually everywhere in Reykjavik. The architect, the late Guðjón Samúelsson, was inspired by the shapes created when lava cools into basalt, a ubiquitous feature of the Icelandic landscape.

Also glowing green on St Patrick's Day were the great domes of another famous city landmark, the Perlan (Pearl). Over 25 metres high, standing on a hill, these vast hot water storage tanks have been updated and a large observation deck placed on them, with an amazing 360° view of Reykjavík and the surrounding area.

Another landmark greened was the Harpa concert and conference hall, whose steel framework clad with geometrically shaped glass panels of different colours went all green.

The Polar Ship *Fram*, Oslo, Norway

Most greenings, by their nature, are outdoors, but one of the most unusual took place inside. It was something of a coup for the Irish Embassy in Norway when one of the country's most famous ships joined the St Patrick's Day festivities for 2015. Housed in the Fram Museum at Bygdøynes in Oslo, the *Fram* is considered one of Norway's most significant historical treasures.

The *Fram* was the first ship in Norway built for polar research, and explored the Arctic Ocean in 1893. The famous explorer Roald Amundsen used it to sail to Antarctica for his South Pole expedition, 1910–12. Small and light, it was strong enough to withstand the huge pressure of pack ice and also comfortable enough for crew who might have to spend years on board.

The Grand Ole Opry House, Nashville, USA

No city in the US has a more tangible connection with Irish music than Nashville, the home of country music. Not only is country music a big favourite in Ireland itself but the music has deep Celtic roots, thanks to the input of millions of Irish and Scottish immigrants over the centuries.

Ruth Moran and her team at Tourism Ireland had been hoping to celebrate this link with a festival in the city for some time. Approaching the Nashville Convention and Visitor Bureau, they were delighted to find that CEO Butch Spyridon was a big fan of all things Irish and enthusiastic to help set up a festival.

The idea was to bring Nashville's stars and the world's best Celtic musicians together to collaborate and celebrate their shared musical heritage. And so the Music City Irish Festival began life in 2014. So successful has it been that what started as a one-day affair now spreads over 17 days.

Having seen how popular the first festival was, Tourism Ireland decided to launch it officially the following year with a visit from CEO Niall Gibbons and a very special greening. Choosing an iconic venue was not difficult. If Nashville is the home of country music in the USA, the Grand Ole Opry House is its most famous stage.

Fortunately, one of the key inspirations behind the festival, Brenda Willis, was a regular performer, with her 12 children, at country music's most illustrious venue, and was able to get the go-ahead for the special night. The Willis family – all talented Irish musicians and dancers – were one of the star turns of the show.

But there was another, less familiar, star to kick off proceedings. Before the performances began, as the Tourism Ireland team waited backstage, Niall Gibbons strode onto the stage, wished everyone a happy St Patrick's Day and switched on the lights that turned the packed 4,000-seater venue green. The applause was deafening!

Nashville is now home to a host of greenings each year, including the AT&T Building, the pedestrian bridge, the Bridgestone Arena and the replica Parthenon.

AT&T Building, Nashville, Tennessee, USA

Other Greenings Around the World, 2015

Avenue of the Arts, Philadelphia, USA

Fitzpatrick Hotel, Manhattan, New York, USA

City Hall, Tbilisi, Georgia

Kalvebod Brugge, Copenhagen, Denmark

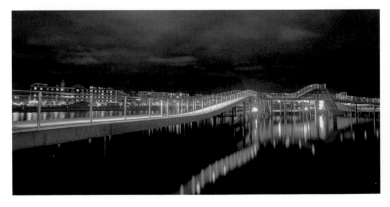

Jumeirah Etihad Towers Hotel, Abu Dhabi, UAE

Museo National de Balla Arts, Santiago, Chile

Edinburgh Castle, Edinburgh, Scotland

Riga Town Hall, Latvia

2016

An Idea Becomes a Tradition

By 17 March 2016 the number of Global Greenings had raced past the 200 mark, something that would have seemed inconceivable back in 2010. The number of participating countries had grown too, as had the range of greenings, great and small. By now a much-loved St Patrick's Day tradition, it had become clear that the greening was here to stay.

There were many memorable greenings this year, including the magnificent Heidecks-burg Castle in the German town of Rudolstadt, arranged by a Donegal expat; the world-famous Bergisel Sprungschanze Stadion Ski Jump in Innsbruck; the freezing ice-swimming in Finland; and the Mount Ulriken TCV Mast, which towers over Norway's second city, Bergen, greening for the first time.

One of the world's most famous sporting teams, the Boston Red Sox, got in on the act, greening parts of their Fenway Park stadium and wearing green training jerseys on the day itself.

There was even a greening at No. 7 World Trade Center in New York, although an even more significant greening at that location would occur in 2017.

Heidecksburg Castle, Rudolstadt, Germany

Karol Kerrane might be the only Irishman living permanently in the historic German town of Rudolstadt, but he has made sure its St Patrick's Day celebrations and greening are enjoyed by all.

It was back in 2012 that Donegal man Karol came to the town, famous for its magnificent baroque Heidecksburg Castle, towering 60 metres above its old quarter. A few years later Karol, who works in business development for an industrial engineering company, was joined by his girlfriend, renowned Scottish artist Selena Mowat. The pair married in the castle in 2016.

That year, Karol had the 'crazy idea' of greening the castle that had such significance in his life in the town he now thought of as home.

His first step was to prepare a presentation for Rotary International, his first target as a potential sponsor. He pitched his idea by presenting a series of photos of high-profile greenings, like the Pyramids of Giza and Sydney Opera House, ending with a photo of Heidecksburg Castle emblazoned with a large question mark.

His initiative was rewarded, and Rudolstadt's first St Patrick's Day greening was approved.

For this greening, Karol experimented with green foil on the town's spotlights before opting for a temporary LED installation to illuminate the castle. On the big day, German revellers festooned in green – and a few visitors from Ireland – congregated on a rooftop car park with great views of the castle before parading with bagpipers to a local pub, where they partied to Irish music.

By the following year interest had skyrocketed and the parade started at the main gates of the 'greened' castle before descending into the town along cobbled streets to two venues hosting traditional music, both of which were packed to the rafters.

By 2018 the local community had fully embraced the initiative, which was officially supported by the Mayor, Jörg Reichl, and the castle's Director, Dr Lutz Unbehaun. More than 20 local businesses generously contributed to the costs associated with the greening as well as financing the music and festivities.

A delegation of officials, musicians and fun-seekers arrived from Karol's home town of Letterkenny and, in response to an official invite from the Rudolstadt Mayor, Donegal

County Council was represented by Letterkenny Mayor Jimmy Kavanagh, Deputy Mayor Michael McBride and Mary Daly.

In sub-zero temperatures, hundreds gathered in the Market Square to hear the mayors reveal their plans for future collaboration between the towns of Letterkenny and Rudolstadt.

The bagpipers led the group up to the impressive castle, where musicians from Donegal were waiting to entertain the crowds in one of its large historic halls. The castle restaurant had even prepared a traditional Irish menu for the day.

Thanks to Karol's persuasive powers, the two towns are now twinned, as officially confirmed in a ceremony on 1 October in Letterkenny.

A delegation of over 40 enthusiasts from Rudolstadt travelled to Letterkenny for the signing ceremony, which was also attended by the German Ambassador to Ireland. A few weeks later students from Letterkenny's Irish-speaking secondary school, Coláiste Ailigh, and teachers from St Eunan's College travelled to Rudolstadt as part of the first student exchange.

The links continue to strengthen. Musicians from Donegal will play at the Rudolstadt Festival, a world music event that attracts over 100,000 people to the town each summer.

Bergisel Sprungschanze Stadion (Ski Jump), Innsbruck, Austria

Standing on the wooded Bergisel Hill, high above Innsbruck in Austria's Tyrol, this world-famous ski jump can be seen from all over town, especially when it is green!

The ski jump is 47 metres tall and can accommodate over 28,000 spectators. It was opened in 2002 and hosts tournaments in January and summer. So delighted were the owners after the inaugural greening in 2016 that it has been held every St Patrick's Day since.

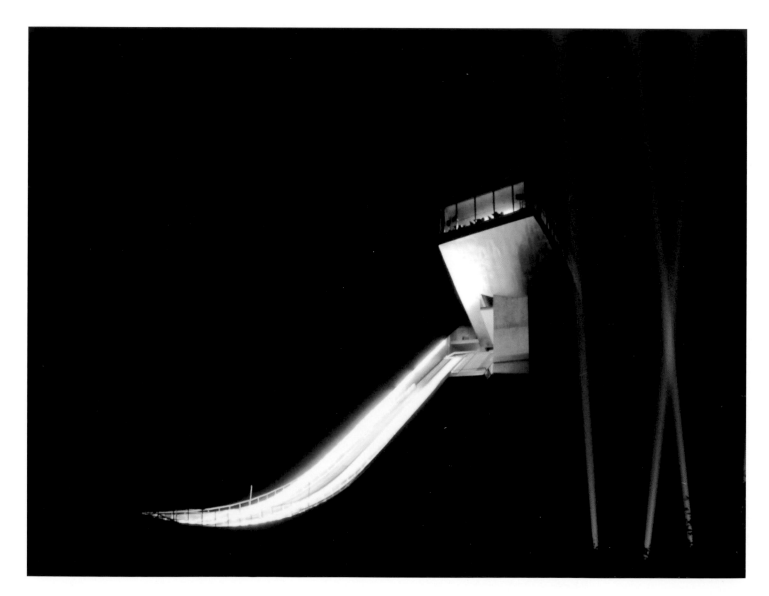

RantaCasino Restaurant, Heinola, Finland

Despite its freezing winters, beautiful Finland has been a popular attraction for Irish expats over the years. Like many, Stephen Cronin married a local, Marika, and the couple started an Irish-themed guesthouse in the town of Heinola. They followed that by opening the stunning RantaCasino Restaurant on a sublime location overlooking the river Kymijoki that runs through the town.

The idea of a greening at the restaurant came after Stephen, who has lived in Finland for over 20 years, travelled to Helsinki for the inaugural meeting of the Irish Finnish Society, of which he is chair. There, Tourism Ireland's Aileen Hickey suggested that the society members get involved in the greening campaign. As a result, Oliver Hussey initiated ice-dipping at Tampere and Charissa McCarron organised a greening at the Radio Towers in Lahti.

Two weeks before St Patrick's Day, Stephen arranged for a local technician to install the green lights around his restaurant and, on the night, he hosted a special St Patrick's Day meal with Irish drinks, attended by Ambassador of Ireland Colm Ó Floinn.

Ice-Swimming Lake and Swimmers, Tampere, Finland

The Irish diaspora worldwide has been responsible for many memorable greenings. One of the most unusual, and probably the coldest, was dreamed up by Irish expat Oliver Hussey. Co-founder with Brent Cassidy of the Irish Festival of Oulu in Finland, Galway man Oliver had settled in Oulu after marrying a Finnish woman. The couple later moved to Tampere, the biggest inland city in the Nordic region, where Oliver works with local economic development agency Business Tampere.

Having worked closely during the festival with the Irish Embassy in Finland and Tourism Ireland, Oliver had been itching to set up a greening in the country from the moment he learned of the concept. But what event could be unique enough to stand out amid the hundreds of Gobal Greenings, and what could best combine Irish and Finnish cultures?

The answer lay in a great Finnish tradition – the sauna! Tampere is known as the 'sauna capital of the world', with over 20 public saunas. Each winter a hole is dug in the layer of ice at the edge of Lake Näsijärvi for sauna-goers to take a 'refreshing' dip. Oliver's idea was to green the walkway leading from the Rauhaniemi sauna to these waters, capturing the volunteers en route to their freezing post-sauna dip.

Friends and colleagues took up the challenge, arranged the lighting (with experts on hand from the city's lighting department) and, wearing green sauna hats, made their way gingerly to the icy waters, a green cloud of steam clinging to them!

Just to add to the Irish dimension, a group of Galway, Clare, Dublin and Kilkenny expats played a hurling match on the ice nearby earlier that day, wearing green hats as well as their respective county shirts and using a special green sliotar.

The Galwegians were victorious! The scenes were captured by photographer Jeff McCarthy, an Offaly man living in Tampere.

So encouraged were they by the global response that the following year Oliver and his colleagues arranged an 'All-Ireland' ice-fishing competition between the counties of Ireland on the same frozen lake. Readers will be glad to know that no fish were harmed in this greening, as none were caught.

Boston Red Sox, USA

When the famous Boston Red Sox baseball team decide to go green, you can bet they do it in style! The decision to green the iconic Fenway Park sports stadium came after discussions with the Irish Consulate in Boston, but it didn't stop there. The team also wore green jerseys on St Patrick's Day for their spring training game in Florida, and not only the inside of the ballpark and the scoreboards but also the notorious 'Green Monster' were greened.

('Green Monster' is the nickname of the highest wall of any Major League baseball field in the US, at a whopping 11.3 metres (37.2 feet). Designed to hide the field and prevent cheap home runs, the wall is a popular target for right-handed hitters.)

Clearly inspired by their greening, the Red Sox went on to win the World Series in 2018.

Mount Ulriken TV Mast, Bergen, Norway

After successful greenings of the Holmkollen Ski Jump and the Polar Ship Fram in Oslo, the Embassy was looking to bring the celebration outside of Norway's capital city. Situated on Norway's west coast and surrounded by mountains and fjords, Norway's second city, Bergen, is steeped in a trading tradition and was once a centre of the Hanseatic League's trading empire. It is home to a small but active Irish community, and members of the Bergen Irish Society (BIS) suggested the TV mast on Ulriken as a location for a greening in 2016. At an altitude of 643 metres above sea level, Ulriken is the highest of the mountains that surround Bergen and the TV mast atop it is visible across the city.

We were concerned that there might be logistical difficulties in lighting such an isolated site. However, when we contacted Lysdans pa Ulriken, the local volunteer association that manages the TV mast, to seek their help, Øivind Johannesen, Atle Tokvam and the team there came on board immediately. They very quickly saw the benefits for Bergen and Ireland and assured us there was nothing to worry about technically – they could turn the mast green, no problem.

On 9 March 2016, I met with the Mayor of Bergen, Marte Mjøs Persen, invited guests and members of the BIS at the foot of Ulriken to switch on the green light, which remained on until after St Patrick's Day. Lysdans pa Ulriken had even devised a special remote-control device to allow the Mayor and myself to switch on the green lights from so far away. The switch hangs in my office in Oslo to this day.

The greening formed part of a week-long Seachtain na Gaeilge organised by the Bergen Irish Society, which included Irish classes, storytelling and parades.

The celebration of Ireland in the city of Bergen and the cooperation and partnership between the Embassy, Tourism Ireland, the Bergen Irish Society and Lysdans pa Ulriken reinforced the historic links between Ireland and the west coast of Norway.

Karl Gardner, Irish Ambassador to Norway

Vasa Ship, Vasa Museum, Stockholm, Sweden

In one of the most disastrous maiden voyages of all time, the *Vasa*, designed as the deadliest warship of its day, sank just minutes after being launched. That was in 1628. The most powerfully armed ship in the world when built, it spent the next 333 years on the seabed before being salvaged to become the world's only preserved 17th-century ship, at Scandinavia's most visited museum.

But might it be argued that the highlight of its long journey was still to come? With encouragement from the then Ambassador of Ireland to Norway, Orla O'Hanrahan, and her colleagues, the great warship joined the Global Greening project in 2016 and has been greened on each St Patrick's Day since.

Wilhelmus-Hubertusmolen Windmill, Weert, the Netherlands

If any landmark could be said to symbolise the Netherlands, it has to be the windmill. That certainly was the feeling of Ruairi Lehmann of Tourism Ireland Netherlands when he was looking for iconic locations for possible greenings. But he was encountering a problem – finding one with floodlights was not proving easy.

The solution came in March 2015 after Ruairi met Irish expat Ger Comyns from Limerick at an Enterprise Ireland event in Amsterdam. Ger lives in the town of Weert, close to the Belgian border, and when he returned home it was his daughter Megan, a big fan of the greenings, who came up with the answer – their local windmill!

Newly refurbished to host a restaurant, OH30, the beautiful Wilhelmus-Hubertusmolen windmill now had floodlights attached. Ger showed photos of some of the most spectacular previous greenings around the world to owner Elvira Maessen and her husband Emile, and they were delighted to participate.

Together with a few friends, including other expats and locals, Ger bought green filters and made frames for the lights. The night was a huge success. Before 2016 few in Weert knew anything about St Patrick's Day, but the green windmill has changed all that.

Ger, family and friends have greened the windmill each year since. In 2018 they worked with another group of locals to arrange a St Patrick's Day party in a local pub, where over 300 people turned up to listen to Cork man Noel Shannon and his wife singing and to watch Irish dancing.

Other Greenings Around the World, 2016

Dom Jose Statue, Lisbon

Brisbane Performing Arts Centre, Queensland, Australia

Elevator Lacerda, Salvador, Brazil

Municipality Building, Nicosia, Cyprus

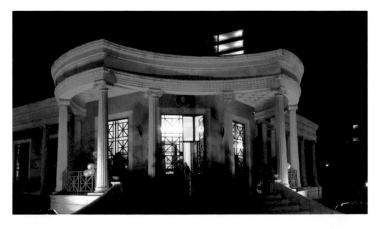

Ada Bridge, Belgrade, Serbia

Yas Viceroy, Hotel Abu Dhabi, UAE

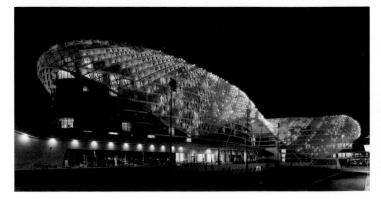

2017

A Deeper Connection and a Lighter Touch

2017 was a year of striking contrasts, from the emotional greening of One World Trade Center in New York to the developing trend of smaller, more light-hearted greenings around the globe.

The Taoiseach of the time, Enda Kenny, hit the switch to transform One World Trade Center. It was a symbolic moment. After the tragedy and terror of 2001, it seemed fitting that the Irish, who have played such an important role in the city over the centuries, should have this connection with the newly reopened tower.

Over more recent years a trend has developed for the unusual, quirky greening. As more and more famous landmarks are enveloped in green for St Patrick's Day each year, the Irish sense of fun has often combined with the local sense of humour to telling effect.

The Australian love of 'Big Things' – huge statues of all kinds of things – now takes on an Irish dimension each March. Big Bananas, Sheep, Kangaroos and even Tasmanian Devils are at the forefront of this trend.

In the Belgian town of Dinant, birthplace of the saxophone, giant saxes representing the EU countries line each side of the Charles de Gaulle Bridge. But only one goes green on 17 March.

One World Trade Center, New York, USA

In 2001 the world watched in horror as the twin towers of the World Trade Center were destroyed. Sixteen years later we shared the sense of hope when One World Trade Center was built in its place. The Irish, historically so much a part of the fabric of New York, were allowed to be part of this spirit of regeneration on 17 March 2017, when then Taoiseach Enda Kenny hit the switch to turn not just One World Trade Center green, but other iconic city buildings too.

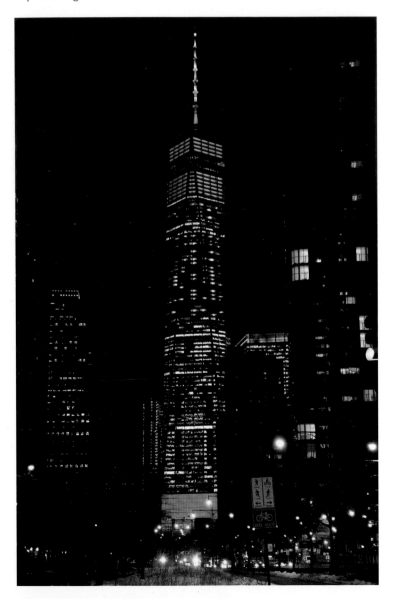

Pozzo San Patrizio (St Patrick's Well), Orvieto, Italy

The most unusual greening of all? One candidate would have to be an ancient well in Umbria, central Italy. However, when you know the well's history, it all makes sense.

St Patrick's Well was built between 1527 and 1537 on the orders of Pope Clement VII, who had fled to Orvieto following the Sack of Rome by the Holy Roman Emperor Charles V. Fearing that the city's water supply would not cope during a siege, he had this 53 metre deep well dug – a miracle of engineering for the time.

The well's name was inspired by St Patrick's Purgatory, a pilgrimage site in Ireland where a vision of Christ reputedly showed St Patrick a cave and told him it was an entrance to hell! In Italy the phrase 'pozzo di S. Patrizio' refers to a bottomless pit or lost cause.

A St Patrick's Festival, including Irish music and literary readings, is now based around this dramatic greening.

The Green Saxophone, Dinant, Belgium

Dinant, birthplace of Adolphe Sax, inventor of the saxophone, honours his invention with 28 giant saxophones – one for each member of the EU – installed on the Charles de Gaulle Bridge. Given the famous Irish love of music, the Irish sax was a natural choice for a greening.

Big Things, Australia

Standing at the entrance to the Trowunna Wildlife Park and Tasmanian Devil Research Centre, the massive (2 metres × 3 metres) Tasmanian Devil was one of the hits of Australia's 2017 greening programme. It took a lot of work, including a long round trip, to get the green lights, but this most unusual of greenings was a huge success.

The Tasmanian Devil is one of over 150 'Big Things' – huge structures which have become so popular in Australia that people plan road trips around them.

Three other Big Things were greened that year, including the Big Banana at Coffs Harbour in New South Wales, thought to be the first ever Big Thing.

The other two were the Big Merino in New South Wales, which celebrates Australia's famous wool industry, and the Big Kangaroo on the border between South Australia and West Australia. The huge 'roo' is holding a jar of Australia's favourite food spread – Vegemite.

Kelpies, Falkirk, UK

These vast horses' heads have become two of Scotland's most famous icons. Standing in the Helix , a large public space alongside the Falkirk Canal extension, they were designed by the sculptor Andy Scott. Thanks to encouragement from Consul General of Ireland to Scotland Mark Hanniffy, the horses became the green giants on St Patrick's Day 2017.

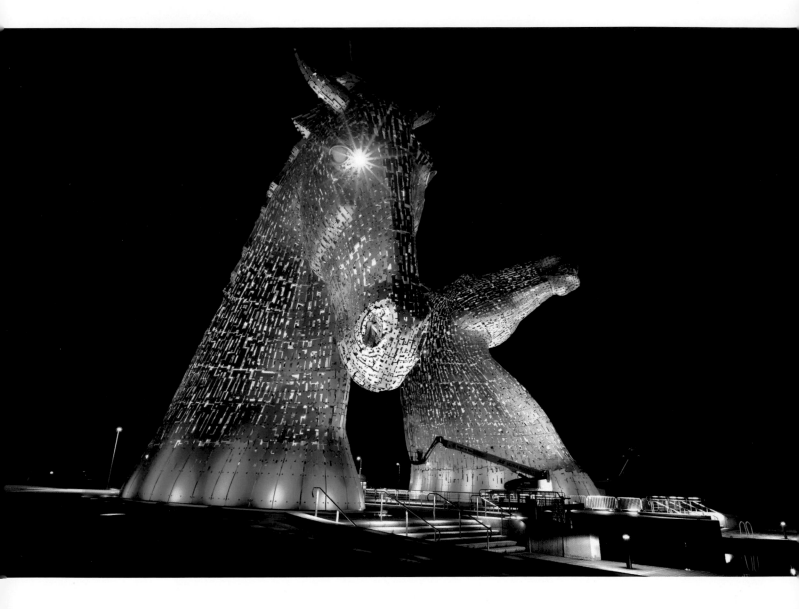

Matsue Castle, Shimane, Japan

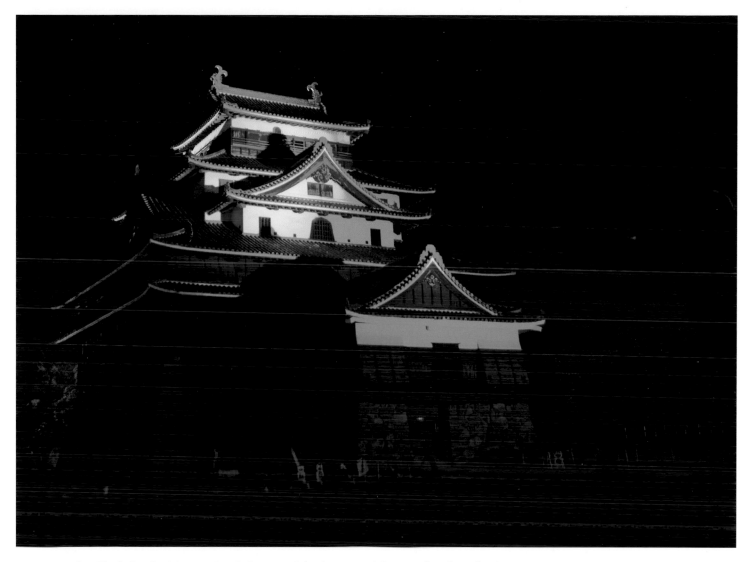

Known as the Black Castle, Matsue Castle is one of the last remaining medieval castles in Japan that retain the original wooden structure. Built in the 17th century, it is one of the three great lake castles of Japan.

Other Greenings Around the World, 2017

Equator Sign, Uganda

Octagon House, Vietnam

Katownia (Executioners House) Gdansk, Poland

Straits Quay Lighthouse, Penang, Malaysia

Mdina Citadel, Malta

Fortress of Maputo, Mozambique

Rhino Statues, Nairobi National Park, Kenya

Ferris wheel, Scheveningen Pier, the Hague, the Netherlands

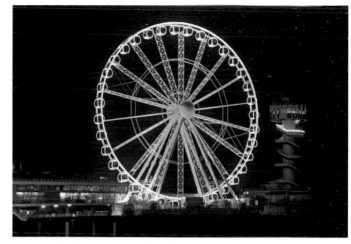

Ethiopia Airlines, Airbus Plane, Ethiopia

City Hall, Seoul, South Korea

Irish dancing, London Underground, UK

Chain Bridge, Budapest, Hungary

Chimo the polar bear, Cochrane, Canada

2018

Pushing Back the Boundaries

By St Patrick's Day 2018, the number of Global Greenings had passed the 300 mark across more than 50 countries. For all those involved it was a moment to reflect on the extraordinary successes of the past nine years, but also to consider how that success could be built on in the years to come. One answer was becoming obvious — ever more creative thinking!

Many greenings had become regular features of St Patrick's Day around the world, and were happening year after year.

These included Rome's Colosseum, the Leaning Tower of Pisa, the Sacré-Cœur Basilica, the Sleeping Beauty Castle at Disneyland in Paris, the Sky Tower in Auckland, Niagara Falls, the Rhine Falls, the Prince's Palace in Monaco, the Manneken Pis in Brussels, Munich's Allianz Arena and the London Eye.

It was also good to see the return of the first greening, Sydney Opera House, after an absence of four years.

When it came to new ideas, a clear theme was developing — let's try something different! The greening of skaters in the Finnish city of Oulu, the work of an enthusiastic expat; the enthusiastic participation of polar bears in Canada; and the greening of a blue whale in London are just a few examples of this increasingly creative direction.

San Mamés Stadium, Bilbao, Spain

Sporting connections between Ireland and other countries are a good source of greenings. Rocco Caira, Irish Honorary Consulate in Bilbao, had been trying for some time to get the owners of the San Mamés Stadium, the home of Athletic Bilbao football club, to consider a greening. In 2018, he finally got the green light.

It wasn't just due to the perseverance of Rocco, who had lived in the area for 30 years. Since a recent refurbishment, the installation of LED lights at the stadium meant the event would be much easier to arrange. Also, a very special Irish connection at the stadium was scheduled just weeks after St Patrick's Day. That duly went to plan when Leinster beat French side Racing 92 in the European Rugby Champions Cup Final.

The connections don't end there. Dublin and Bilbao have since been twinned for the Euro 2020 football competition, while Aer Lingus has recently announced extended flights to the city from Dublin.

Luxor Obelisk, Paris, France

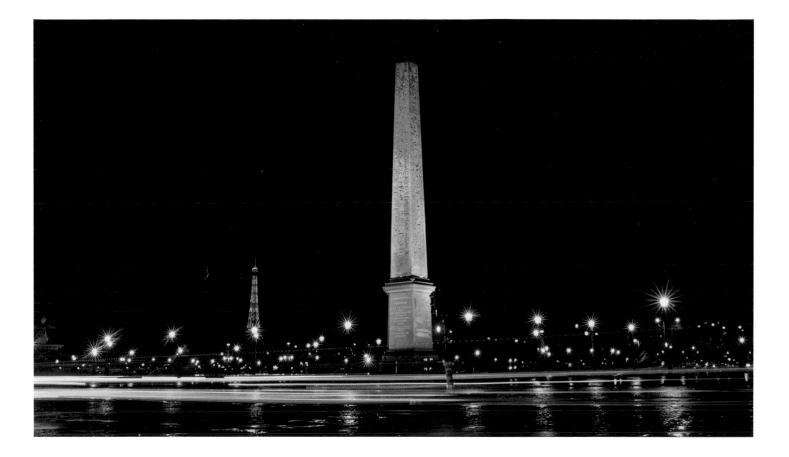

On 25 October 1836, over 200,000 Parisians crowded into the Place de la Concorde to see the Luxor Obelisk (named after the Luxor Temple it originally stood outside) erected. It had taken four years to transport the 23 metres high monument to Paris, partly along the Nile, but it was worth all the trouble as locals took the ancient Egyptian obelisk to their hearts.

It would be another 182 years before the next milestone in the obelisk's French lifetime, when Parisians gathered around it to celebrate its first ever greening!

Publicis Drugstore, Paris, France

On 17 March 2018, the biggest lighting frontage over the Champs-Élysées turned green with a special message for the day – '#StPatrickEnVert, thrill to Ireland's rhythm', followed by a giant projection of the Tourism Ireland logo.

The frontage belongs to the Drugstore Publicis, which is also the French HQ of Tourism Ireland's ad agency, Publicis.

Luxor Obelisk, Paris, France

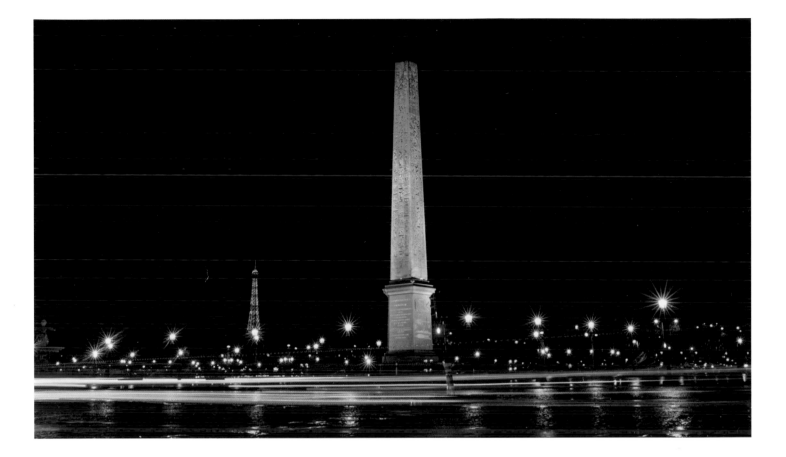

On 25 October 1836, over 200,000 Parisians crowded into the Place de la Concorde to see the Luxor Obelisk (named after the Luxor Temple it originally stood outside) erected. It had taken four years to transport the 23 metres high monument to Paris, partly along the Nile, but it was worth all the trouble as locals took the ancient Egyptian obelisk to their hearts.

It would be another 182 years before the next milestone in the obelisk's French lifetime, when Parisians gathered around it to celebrate its first ever greening!

Publicis Drugstore, Paris, France

On 17 March 2018, the biggest lighting frontage over the Champs-Élysées turned green with a special message for the day – '#StPatrickEnVert, thrill to Ireland's rhythm', followed by a giant projection of the Tourism Ireland logo.

The frontage belongs to the Drugstore Publicis, which is also the French HQ of Tourism Ireland's ad agency, Publicis.

Canada

Chimo the polar bear, Cochrane, Canada

Chimo means 'be welcome' in the Native American Cree language. What better name to embody the spirit of a St Patrick's Day greening? This famous statue is in Cochrane, the starting point of the Polar Bear Express, a train that travels the farthest north in the province of Ontario you can go – which is why the polar bear is Cochrane's mascot.

Cochrane Polar Bear Habitat, Canada

The bears at the only captive bear facility in the world dedicated solely to polar bears enjoyed an unusual breakfast of shamrocks on 17 March 2018.

The Big Nickel, Sudbury, Canada

This giant replica of a 1950s Canadian five-cent coin is nine metres tall! It stands in the grounds of the Dynamic Earth science museum in Sudbury, Canada.

The Wawa Goose, Canada

Another 2018 Greening, this 8.5 metre metal goose statue stands along the Trans-Canada Highway, just outside the small town of Wawa in northern Ontario.

The Big Fiddle of the Ceilidh, Cape Breton, Canada

What could better symbolise the love of music that unites Canadians and Irish than greening the world's largest fiddle? With its vibrant Celtic heritage, it is believed that this beautiful island in Nova Scotia has more fiddlers per capita than anywhere else on the planet!

 To accompany this greening, leading Irish and Canadian musicians put on a scintillating show of Celtic roots music.

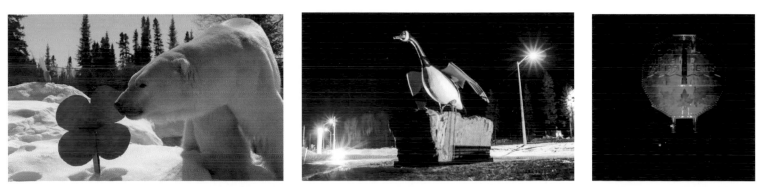

Hope, the Green Whale, London, UK

This vast 25-metre blue whale skeleton, known as Hope, has been suspended from the ceiling of London's Natural History Museum for decades. As it was discovered on the shores of Wexford, part of Ireland's Ancient East, Tourism Ireland GB thought that Hope was an ideal candidate for a greening.

And so, on 17 March 2018 the blue whale turned green and this photo was seen by millions around the world.

The Greening of Oulu, Finland

It is perhaps surprising that it took until 2018 for the Northern Finnish city of Oulu – just 200 kilometres from the Arctic Circle and known as the Irish cultural Mecca of Finland – to celebrate its first greening. It was back in 2006 that Brent Cassidy, along with several friends, founded the Irish Festival of Oulu.

The October festival, which has attracted 87,000 people since 2006, offers five days of Irish music, film, dance, theatre, poetry and food. It has hosted bands as prestigious as The Chieftains as well as award-winning theatre performances and acclaimed poets like Paul Muldoon and Michael Longley.

Festival Director Brent had wanted to stage a greening for some years, and finally got the go-ahead from the Oulu Culture Department for St Patrick's Day 2018. Locals and visitors, including Ambassador of Ireland Maeve Collins, looked on as the ice rink in the city's historic harbour area and the iconic Oulu theatre's 'hat' were lit in glorious green.

One of the key figures in Oulu's Irish musical life, Markus Lampela, led skaters of all ages while playing the tin whistle, thus perfectly blending Irish and Finnish culture.

Dubai Duty Free, United Arab Emirates

The number of greenings created by influential members of the Irish diaspora continues to grow. In 2018 these included the greening of Dubai Duty Free (DDF) Tennis Stadium, which owed much to its Irish Chief Executive Officer and a little-known part of Irish history.

When the owners of Dubai International Airport were looking to enhance their duty-free outlets at the airport back in the early 1980s, they asked Aer Rianta – the company behind the duty-free operation at Ireland's Shannon Airport – to present a proposal. Why Aer Rianta? Shannon had become the world's first duty-free airport in 1947 and has remained a model for duty-free operations around the world to this day.

Among the 10-strong Aer Rianta team contracted to set up the operation was Colm McLoughlin, originally from Ballinasloe in County Galway, who has served since 1984 as the Chief Executive Officer of DDF. In that time DDF's annual turnover has grown from around US$20 million to a little under US$2 billion. So, in a way the greening was a celebration of the Irish contribution to one of world travel's most successful operations.

Dubai Creek Golf & Yacht Club, United Arab Emirates

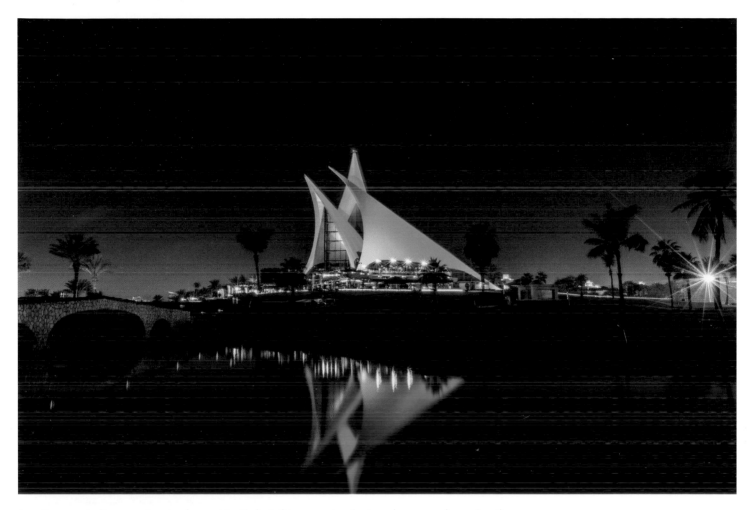

Another great diaspora-inspired event in Dubai, this greening featured a man whose family created the most famous Irish export of all. The credentials of Lord Iveagh — co-founder, with Grant Muskett, of the Golf, Guinness and Oyster Gathering — are clearer if you know his full name, Arthur Edward Rory Guinness.

The Golf, Guinness and Oyster Gathering hosts events at top golf clubs around the world to facilitate business networking and raise funds for the Iveagh Trust, which provides affordable rented housing to people on low incomes.

When the Dubai Creek Golf & Yacht Club hosted the Gathering on St Patrick's Day with Lord Iveagh in attendance, the greening of its clubhouse, designed like the sails of the traditional Arab dhow, was more or less unavoidable! Overlooking the tranquil Dubai Creek waterfront, the greening could be seen from miles away.

Greenings on the Island of Ireland

Minister for Tourism Leo Varadkar encouraged greenings back home on the island of Ireland to mirror the success of the Global Greenings. Institutions, organisations and individuals in Northern Ireland were also inspired by the Global Greenings and wanted to get involved. Here is a small selection of buildings and iconic locations across the island of Ireland that went green, including the Four Courts in Dublin, Titanic Belfast, Trinity College Dublin, the Giant's Causeway, Stormont Buildings Belfast and North Bull Lighthouse in Dublin Bay.

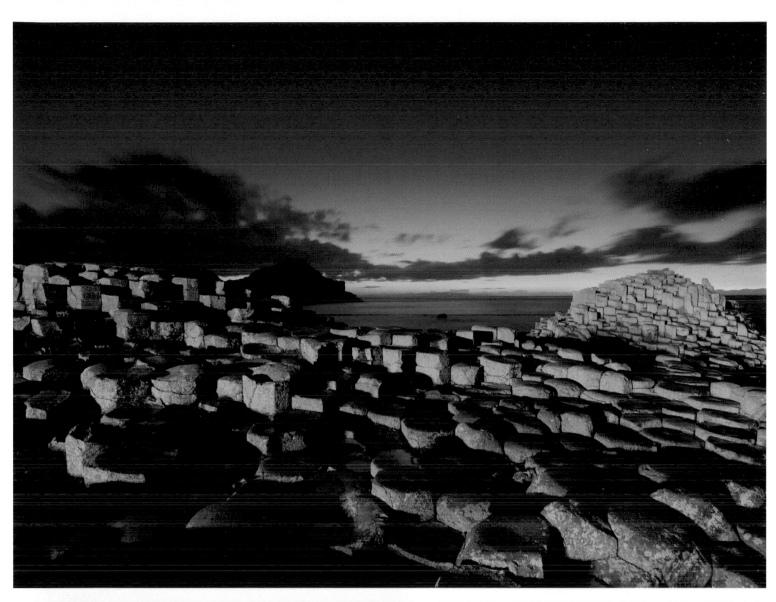

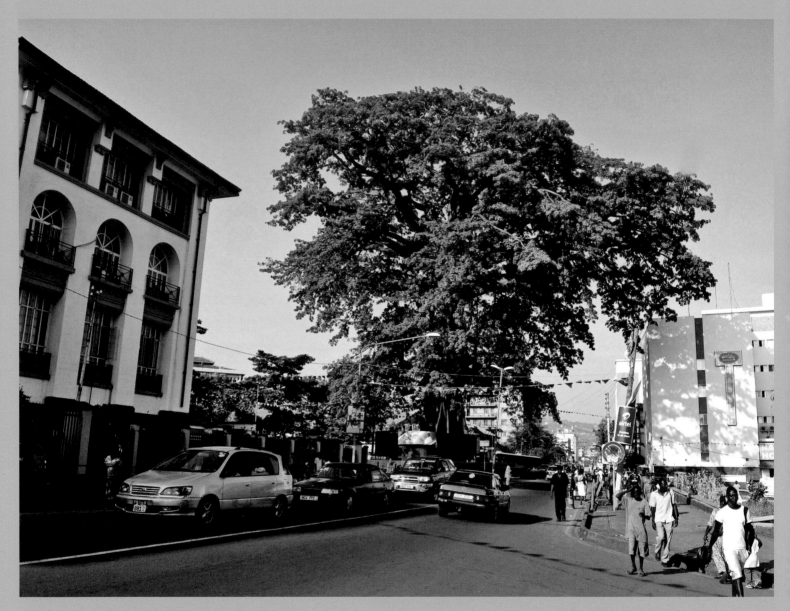

Cotton Tree, Freetown, Sierra Leone

2019 and Beyond

The Future Is Green

When the greenings were first envisaged, no one could have imagined the extraordinary impact they would have or their sheer scale and diversity. Greenings have been spectacular and intimate, cultural and quirky, historic and contemporary. Most of all they have become a symbol of friendship between Ireland and the world. Just like the parades and parties, the greenings are an established tradition of a national day that is a global celebration.

The potential to build on this goodwill and the ever-deepening network of relationships that create the greenings is limitless. Each year more countries and more landmarks come to the party. On this annual celebration of Ireland's patron saint, the Irish are granted a great honour – to share the culture and history of another country.

Nowhere will this honour be more deeply felt than in one of the exciting new greenings for 2019, the very first in Sierra Leone. The greening here will be of the ancient cotton tree in the heart of its capital, Freetown. The huge tree has enormous significance both for Freetown and for the struggle against slavery. It was here in 1792 that that a group of African American slaves, granted their freedom after fighting for the British during the American War of Independence, are said to have rested and prayed on their arrival. They went on to found the city of Freetown, which became a haven for emancipated slaves. The great cotton tree is now a symbol of freedom and a revered location for the people of Sierra Leone.

The story of the greenings is only just beginning!

Acknowledgements

Tourism Ireland would like to thank the following for their contributions to this book: Tourism Ireland staff around the world; Ireland's ambassadors and embassy and consulate staff; Karol Kerrane and Selina Mowat; Matthias Fleckenstein; Ray and Orsi Bradshaw; Oliver Hussey; Brent Cassidy; Ger Comyns; Massimo Capra; Ben Finnegan; Stephen and Marika Cronin; Hubertus Winkelmolen; Irish Pubs Association of Germany (IPAG); Jan O. Deiters and Anna Soldan; Siobhán Kelleher-Petersen; and Richard Branson.

Photograph credits: All photographs reproduced in this book are courtesy of Tourism Ireland, with the exception of – Sjoerd van Hoof, Wilhelmus-Hubertusmolen Windmill, p. 131; Ben Finnegan, Salamanca, pp. 38–9; Jan O. Deiters, Bad Homburg Castle, p. 67; Jeff McCarthy, ice-swimming/hurlers, p. 127; Siobhán Kelleher-Petersen, *The Little Mermaid*, p. 60; Áine Keogh, *Little Mermaid* illustration, p. 60; Christina Fadler, Wiener Riesenrad Ferris wheel, p. 88; Tom Bause, Bergisel Sprungschanze Stadion (Ski Jump), p. 124; Tourism Ireland/APA-Fotoservice/Ludwig Schedl, Burgtheater, p. 46; Giuseppe Voci–Latitudine41, Colosseum and gladiators, p. 113.

Tourism Ireland global team marking the 20th anniversary of the Good Friday Agreement with Minister of State Brendan Griffin TD.

Tomorrow the Moon?